IMAGES
of America

# KAUAI

ON THE COVER: Around 1900, Henry Funk photographed this *hale* on the property of Alii Kekaihaakulou (Deborah Kapule's Hawaiian name). After Kaumualii's death, the former queen of Kauai lived in her *hale pili* (grass hut) on her lands near the Wailua River. She was known for her hospitality. Before hotels, travelers knew they could stay with her. Historian James Jarves met her in 1837 and wrote, "She lived in a beautiful spot . . . whence a river led inland to a noble waterfall . . . that looked more like park scenery than a wild work of nature." He traveled up the river with her in a double-hulled canoe to the foot of a steep hill that he climbed to view the Wailua Falls. (Courtesy Kauai Museum.)

# IMAGES of America
# KAUAI

Stormy Cozad

Copyright © 2008 by Stormy Cozad
ISBN 978-0-7385-5644-4

Published by Arcadia Publishing
Charleston, South Carolina

Printed in the United States of America

Library of Congress Catalog Card Number: 2008924286

For all general information contact Arcadia Publishing at:
Telephone 843-853-2070
Fax 843-853-0044
E-mail sales@arcadiapublishing.com
For customer service and orders:
Toll-Free 1-888-313-2665

Visit us on the Internet at www.arcadiapublishing.com

*This book is dedicated to the memory of my great-grandfather, Walter Benedict Thompson, with whom I share a profound love for photography, and my brother Walter Lee Cozad, with whom I share a fascination with writing and history.*

# Contents

Acknowledgments — 6

Introduction — 7

1. King Kaumualii and Waimea — 9
2. Hanapepe — 21
3. Missionaries and the Port of Koloa — 29
4. Sugar, Pineapple, and Rice — 45
5. A Queen, a Scot, and an Architect — 59
6. Modes of Transport — 71
7. A Bird's-Eye View — 81
8. You Can't Get There from Here — 89
9. Kaikioewa and Lihue — 109

# Acknowledgments

No one writes a book alone. It took an island to write this book and many, many generous people who shared their time and knowledge with me.

I could not have done it without the staff of the Kauai Museum, especially Margaret Lovett, who cheered me on in the beginning, and Chris Faye, who jumped in with both feet at the end. Being an author herself was really helpful at crunch time. I also want to thank Carol Lovell, the past director, for her willingness to answer questions; Roy Miyake for his information and encouragement; and Ralph Leaman for finding all the photographs.

The great staff at the Kauai Historical Society, Pres. Randy Wichman, and Executive Director Mary A. Requilman, will have my gratitude forever for the advice and historical knowledge they shared with me.

Carol White, head librarian of the Mission Houses Museum Library, gave me invaluable advice for possible missionaries to include.

Special thanks to those who answered my questions or were willing to be interviewed, including Henry B. Wolter of the U.S. Geological Survey, Aletha "Puna" Kaohi, Kumu Hula Roselle Bailey, Kumu Hula Jessi Jardin, Pat Griffin-Noyes, Bev Harter, Bob Schleck, David Penhallow, Barbara Richter, Cheri Atkins, Dorothy Cataluna, Carol Hamamura, Eiko Senda Murakawa, Frank Santos, Kuulei Santos, and Philip and Pat Palama.

There are not enough words to thank my husband, Gaetano Vasta, for all the technical help and support he gave me with this project. *Grazie mille*.

To these I forgot to mention and others who wished to remain anonymous, *Mahalo Nui Loa*.

Please forgive any errors found; they were unintentional. At the preference of the author, use of the *okina* has been omitted.

# INTRODUCTION

Kauai has a rich history. Its origin is volcanic. It is the oldest of the four main Hawaiian Islands and the only leeward island that tourists can visit today. According to Chuck Blay and Robert Siemers in their book, *Kauai's Geologic History*, the oldest rocks on Kauai are 5.1 million years old, while the youngest are 520,000 years old.

Kauai is an island county. It is perhaps the most isolated land mass. It is 90 miles away from the next island county, Oahu, and roughly 2,500 miles away from the mainland United States. It is 4,000 miles away from Asia. Even Tahiti and the other islands of Polynesia, from which some of Kauai's ancestors are thought to have come, are 3,000 miles away.

The story of Kauai is not unlike the story of any place that is coveted by another. Historians are fairly sure there were people living here as far back as the fourth or fifth century A.D., when the Marquesans and later the Tahitians came to these shores. What they were like and what their language was like have been lost. It is known that the Menehune were great stonemasons and there are examples of their fine stone cutting skills, as seen by the Menehune ditch and the wall of the Alekoko fishpond. The skills they possessed disappeared over time. In an early 1800s census, as many as 65 people listed their lineage to the Menehune, according to an article written by John M. Lydgate.

Kauai passed peacefully unnoticed for centuries by the larger outside world. That is not to say no foreigners or random explorers found the island, but no one thought it important enough to share what they found with the world. Due to its isolated location, it stayed undisturbed by plagues and famines for centuries. War was part of the Hawaiian culture, but most weapons were used in hand-to-hand combat. Kauai was considered the most peaceful of the islands. It was called *Kauai Malie* or calm Kauai. With Capt. James Cook came metal, guns, and disease. With whalers and other ships that followed came the concept of debt, more disease, and a curiosity about the outside world.

Kauai quickly went from a monarchy to a territory to a part of a state in less than 200 years. It is somewhat ironic the descendants of the settlers who first colonized America from Plymouth Rock in 1620 set out from Boston and landed on Kauai in 1820 to enlighten the Hawaiians.

Capt. Nathaniel Portlock, in his journal aboard the *King George*, wrote about the first Christmas on Kauai in December 1786. Capt. George Dixon on the *Queen Charlotte* and Portlock were both moored at Waimea. He wrote about passing out small presents to the local women and children and was surprised when High Chief Kaiana returned gifts of pigs and vegetables to the ship.

Capt. John Meares stopped at Waimea in 1787 on his way to Canton, China. When he left, he had High Chief Kaiana on board as well. Many asked to see the world outside Kauai, but the captain only took the brother of the king. Only later did Kaiana realize how jealous this had made his brother Kaeo.

Capt. George Vancouver, who had been a junior officer on the voyage to the Sandwich Islands with Cook, found himself again in the islands in 1792. It was then he first met Kaumualii. Kaumualii's father, Kaeo, was off the island, and he was in the care of a *kahu* or retainer (caretaker). Kaumualii

was about 12. Vancouver thought the prince was friendly and intelligent. He probably thought him precocious as well, since he wanted to be called "King George" after the king of England.

As an adult, Kaumualii was considered in his day to have one of (or the) highest-ranking lineages. For this reason, chiefs from other islands wished to conquer him and his territory. As history tells us, Kauai was never conquered. However, to keep Kauai as it was, Kaumualii wisely gave his allegiance to Kamehameha I in 1810 and was able to retain power on Kauai while paying tribute to Kamehameha. This lasted until the death of Kamehameha I in 1819. Kamehameha II Liholiho, at the urging of Kamehameha I's favorite wife (now widow) Kaahumanu, came to Kauai. It is said that Kaumualii paid homage to Liholiho as he had his father before him. Kaumualii told him that all Kauai was his. Liholiho slyly said no, he did not want it. He told Kaumualii he could continue ruling as he had been. Figuring the issue had been settled, the two *alii* celebrated for days. By this time, both rulers had small ships of their own. Liholiho brought his over from Oahu, and they sailed around Kauai. One evening while Kaumualii was dining with Liholiho on his ship, it weighed anchor with Kaumualii still on board. He had been kidnapped. He never lived on Kauai again. Arriving on Oahu, Queen Kaahumanu forced both Kaumualii and his son Kealiiahonui to marry her, and thus the assimilation of Kauai was complete. Kaumualii was dead within three years. He is buried on Maui.

It was not until the death of Kaumualii that things really changed for Kauai. Kaumualii's son George Humehume returned to Kauai in 1820 with missionaries and was told by his father that he would succeed to the throne. Kaumualii gave him the fort and told the other chiefs to follow Humehume upon his death. Knowing this, it is not surprising that he tried to reclaim Kauai. The uprising was quick and bloody. The other chiefs from Kauai were rounded up, their lands taken away, and they were deported to live in exile on other islands far away from their friends, family, and power base to prevent any further uprisings.

Sandalwood, whaling, missionaries, sugar, pineapple, and tourism each impacted the island. With each change, Kauai has reinvented itself. The island has had its share of famous people, but Kauai itself is its most famous product. Kauai has charmed people for centuries.

If one looks at the early maps made by Captain Cook, all the islands when said phonetically are similarly pronounced today, except Kauai. It has appeared on maps as Atooi, Attowai, Tauwai, and by 1824, Tauai, which is similar to today's spelling. K and T were dialectically interchangeable, depending on who was speaking and who was listening. Hawaiian sounds were foreign to the earliest visitors' untrained ears. Rev. Samuel Whitney wrote about Tauai and visiting Toloa. Rev. William Ellis, a missionary who spent considerable time in Tahiti, was used to the T sound over the K sound as well as felt Atooi was two words, as one says O Hawaii and Oahu.

There are many interpretations of the meaning of Kauai. William Hyde Rice, who had an accustomed ear to Hawaiian speech since he had heard it from birth, espoused the one that captures the imagination. He felt that the accent on Kauai should be on the second *a* without the glottal break between the last two letters. This way the meaning is "the fruitful season" or "time of plenty." It is said this name was given in ancient times because Kauai was the only island of the group that never suffered from famine on account of drought. That is true to this day. There is an old native proverb that says, "All good things come to Kauai at last."

# One
# KING KAUMUALII AND WAIMEA

The ancient Hawaiians believed land and water belonged to the gods. Land was important, but land without water was nothing. To the Hawaiians, water was wealth. The word *wai* means "water," but *waiwai* means "prosperity." They developed a very sophisticated land management system of *mokus* and *ahupuaa*. Kauai is divided into five *mokus* (districts): Kona, Na Pali, Halelea, Koolau, and Puna. Within each moku were usually several ahupuaa. Each ahupuaa needs its own water source. Today this sometimes appears not be the case, because the water source has been diverted or has dried up. Most ahupuaa run from the mountains to the sea. The largest ahupuaa on Kauai is Waimea in the Kona Moku.

Waimea, which literally means "reddish water," was one of Kauai's largest population centers in ancient times before Captain Cook. Waimea was the capital of the Kona Moku. *Kalo* (taro) was grown here using a vast irrigation system. They also grew coconuts, bananas, and lesser-known foods such as breadfruit and *ko* (sugarcane).

Due to Waimea's drier climate, the chiefs would leave Wailua, the wetter location in the Puna Moku, and spend the winters in Waimea. King Kaumualii made Waimea his permanent residence because the newly published maps of Hawaii listed Waimea as the port of call. In the 1800s, it was a busy place to be. Waimea continued to be a port of call until better harbors at Port Allen and Nawiliwili could be built in the late 1920s and early 1930s.

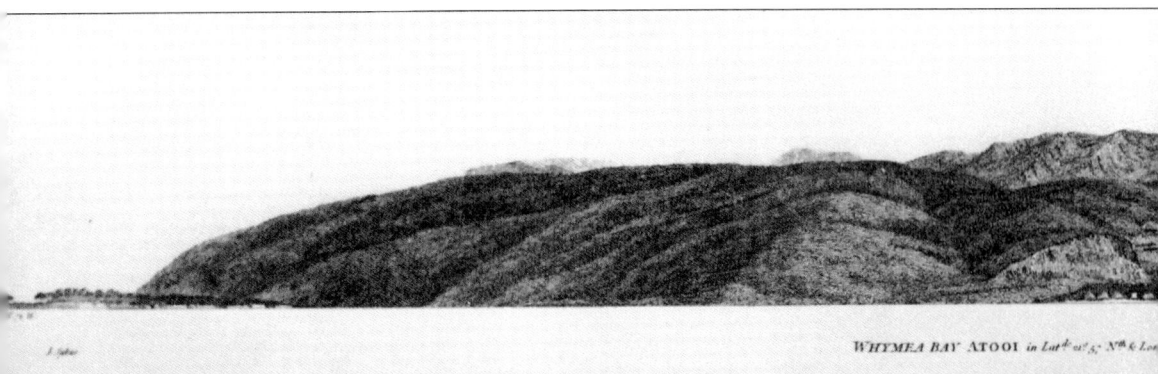

This was Capt. James Cook's first view of Kauai as seen from the sea. Because of ears untrained to the Hawaiian language, all the names were spelled phonetically on Captain Cook's early maps.

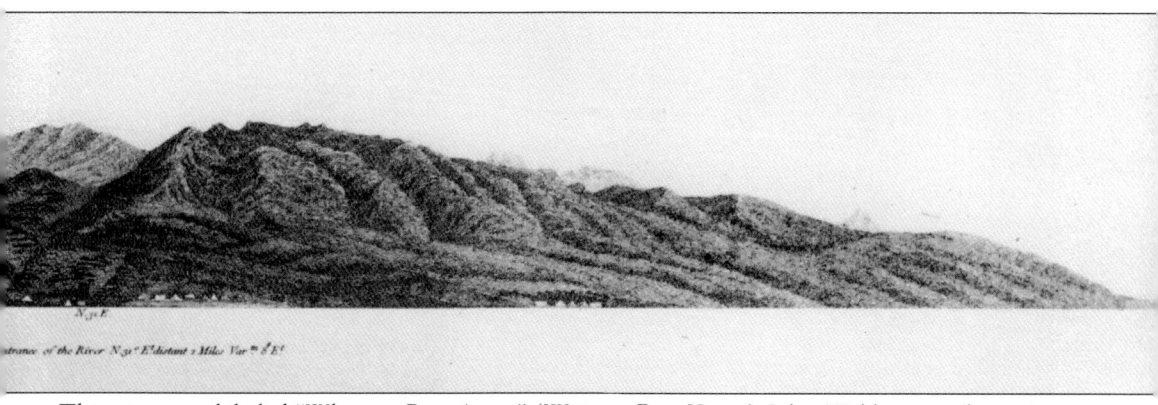

This view was labeled "Whymea Bay, Atooi" (Waimea Bay, Kauai). John Webber was the artist on board Captain Cook's ship. (Courtesy Kauai Museum.)

This 1880s photograph taken at the mouth of the Waimea River with a ship at anchor gives one a glimpse of what Captain Cook's arrival might have looked like to those from shore when he first discovered the islands in 1778. (Courtesy Kauai Museum.)

John Webber sketched Heiau Kealii, dedicated to Lono-nui-akea, during Cook's 1778 expedition. The *heiau* was located in a temple complex area known as Ka naa naa. The exact location of the heiau is not known today, although some guess it was near the Waimea Foreign Church. (Courtesy Kauai Museum.)

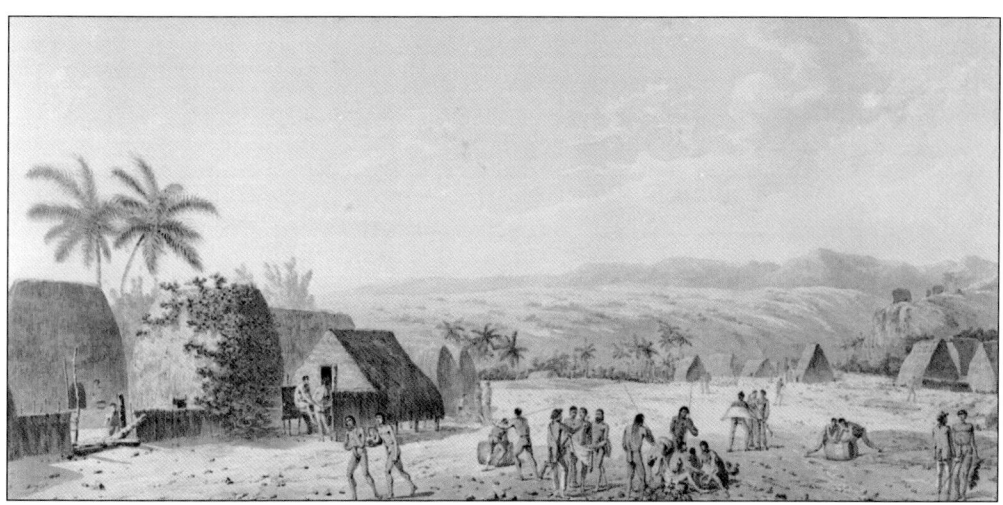

The sketch above, drawn by John Webber, is the earliest view available of what Waimea looked like in 1778. The houses were grass. Clothing was light or unnecessary in the warm Waimea climate. The drawing shows that some are wearing *malos* (a type of loin cloth) and *tapa* drapes. Chief Kaiana, below, was a Kauai alii and brother to Kaeo and uncle to King Kaumualii. In 1787, Capt. John Meares took Kaiana with him to Canton, China. He had wanted to go to England. He traveled as far as the Pacific Northwest before taking a ship that returned him to Hawaii. His most prized possession from his adventure was the painting of himself painted by an English artist in Canton. He was a very handsome man, over 6 feet tall, and is shown here wearing the emblems of his high rank: the feather helmet and cape. (Both courtesy Kauai Museum.)

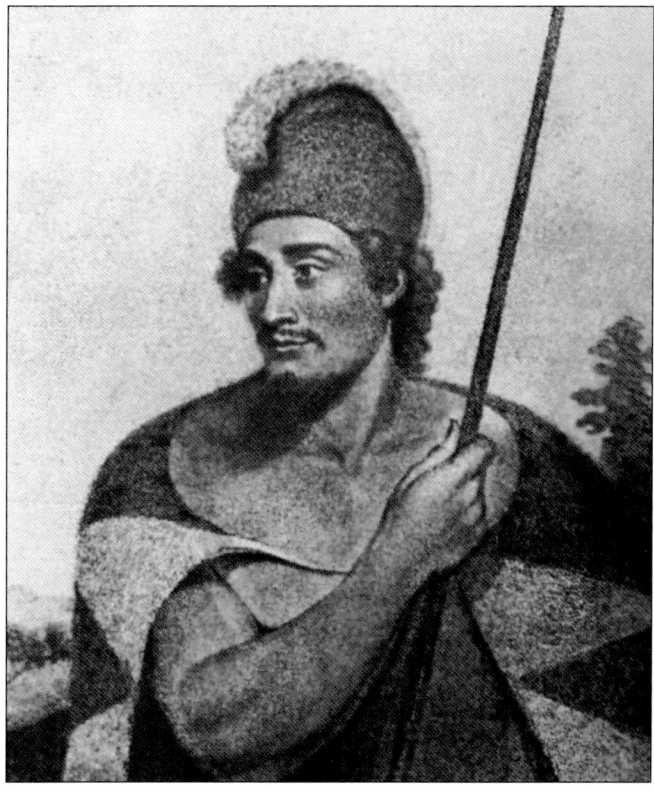

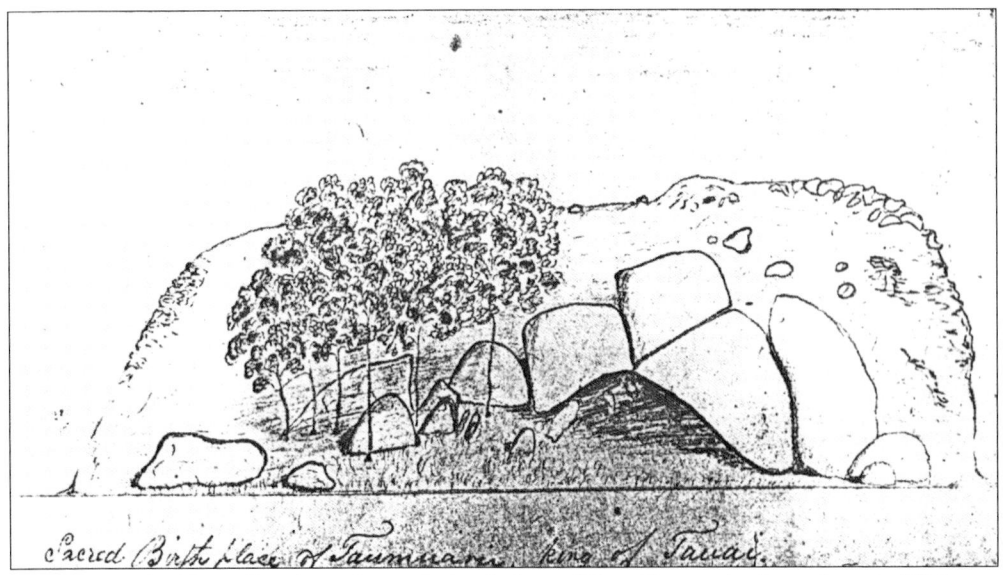

This drawing by Hiram Bingham shows the birthplace of King Kaumualii. Being born in Wailua at Pohaku Hoohanau (the birthstone) insured a child high-ranking status. Bingham traveled around the island many times giving sermons in the various villages. (Courtesy Kauai Museum.)

Tourists can still visit the Heiau Holoholoku in Wailua. This photograph taken by Reva Stiglmeier in the late 1970s shows Bill Kukuchi, a well-known professor of anthropology at Kauai Community College and favored lecturer, giving a talk about this royal birthstone and the Wailua area. (Courtesy Kauai Historical Society.)

This is a reproduction by the American Board of Commissioners for Foreign Missions (ABCFM) of a letter sent by Kaumualii to his son George in 1819, one year before George arrived on the first missionary ship, the *Thaddeus*. Since Kaumualii did not learn to read or write until after 1820, the letter was obviously dictated and cannot be counted on to be accurate. (Courtesy Kauai Museum.)

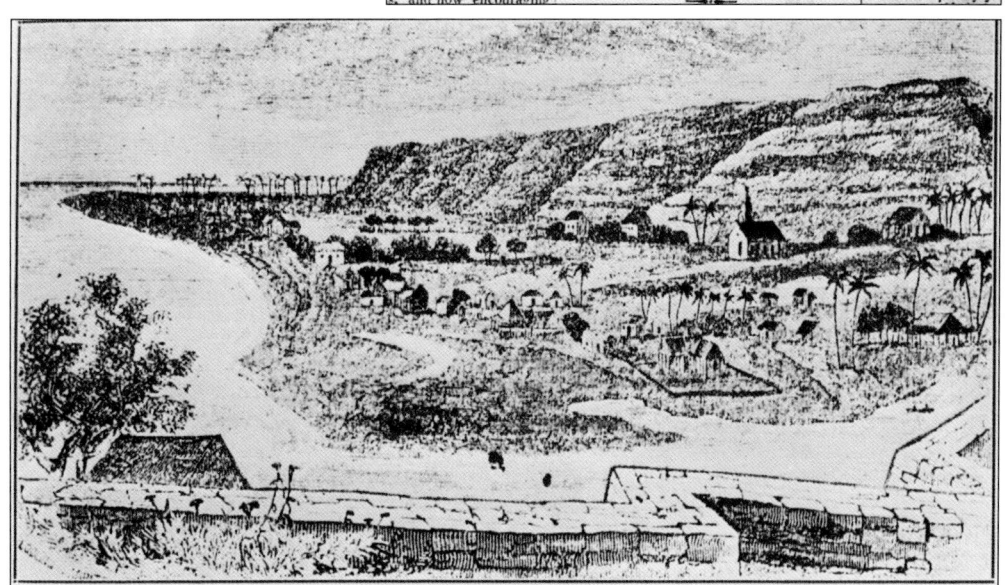

This 1853 G. W. Bates sketch, drawn from above the river, is a more accurate drawing looking westward toward the village. The walls of the Russian Fort Elizabeth were 17 feet thick with the riverside part in the shape of a star. The Russians never completed the star shape. George Scheffer built the fort in 1816. Scheffer had promised Kaumualii help from Russia but had no authority to do so. Rather than incur wrath from either Kamehameha or Russia, he fled to Brazil. (Courtesy Kauai Museum.)

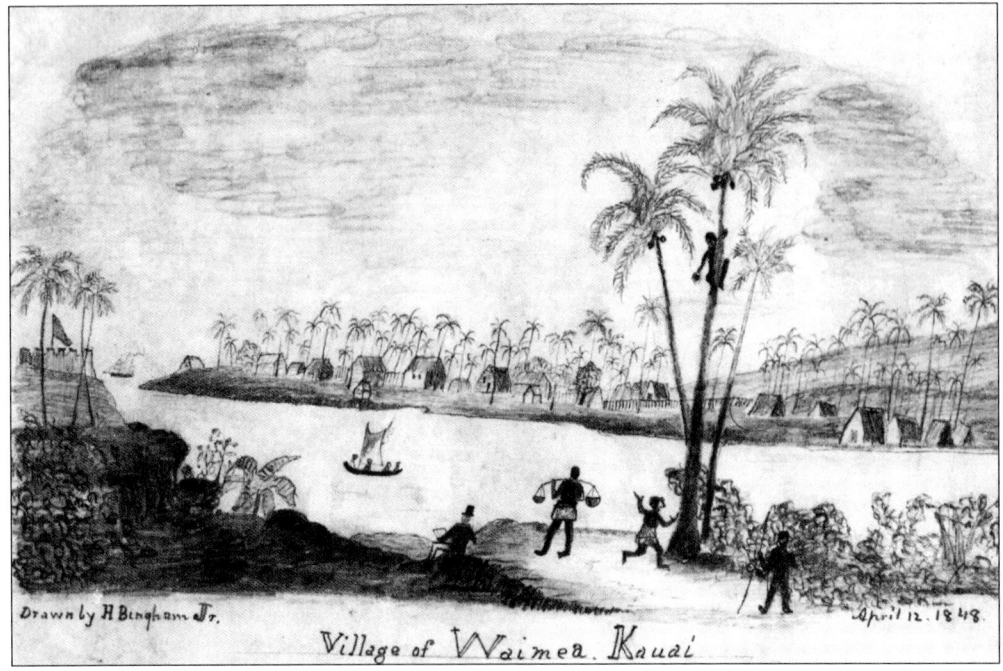

The view of Waimea above was supposed to be drawn in 1824 from below and to the right of Fort Elizabeth. Scholars are quick to point out the drawing is highly inaccurate. The primary reason is the drawing shows far too many huts close to the river. The land near the river was marshy. H. Bingham Jr. drew this sketch, entitled *Village of Waimea, Kauai, April 12, 1848*, likely using a drawing from his father's book as his model. When Hiram Jr. drew this, he was going to school in New England. Both drawings are duplicated here for a comparison. Although J. W. King took the below photograph of the Waimea River in 1860, it is a far more accurate view of Waimea than the Bingham drawings. Note the lack of pili grass huts along the shoreline. It was a swampy place prone to flooding. (Both courtesy Kauai Museum.)

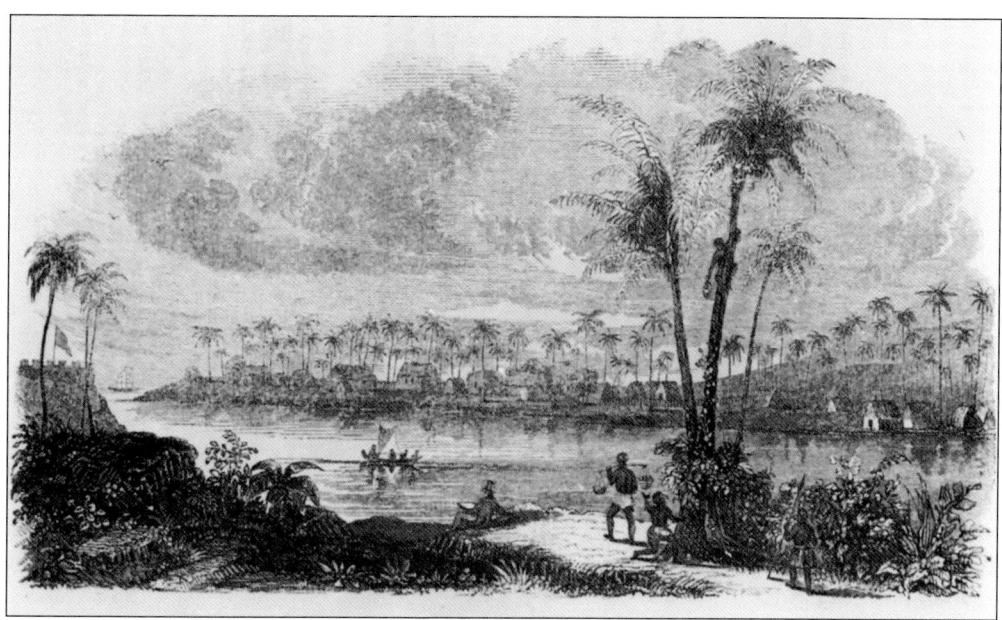

The drawing above is from Bingham's book, *A Residence of Twenty-One Years in the Sandwich Islands*. Kaumualii's son George Humehume was on the same ship as Bingham. On the manifest, "George" was listed as an interpreter. Years earlier, progressive-thinking Kaumualii sent his seven-year-old son to New England to be educated. However, the ship captain just left the boy. He worked many jobs, even enlisting in the U.S. Navy and fighting in the war of 1812. He became a student at the Foreign Mission School in Connecticut, which led to his return to Kauai. *Cleopatra's Barge*, below, was built in 1816 as the first U.S.-built, deepwater pleasure yacht for $50,000. It was 83 feet long with two decks. In 1820, it was sold to King Kamehameha II for $100,000 in Sandalwood and renamed *Haaheo o Hawaii*, or *Pride of Hawaii*. In 1821, Liholiho used it to lure King Kaumualii aboard for dinner and kidnap him. Three years later, the vessel sank in Hanalei Bay. (Both courtesy Kauai Museum and Kauai Historical Society.)

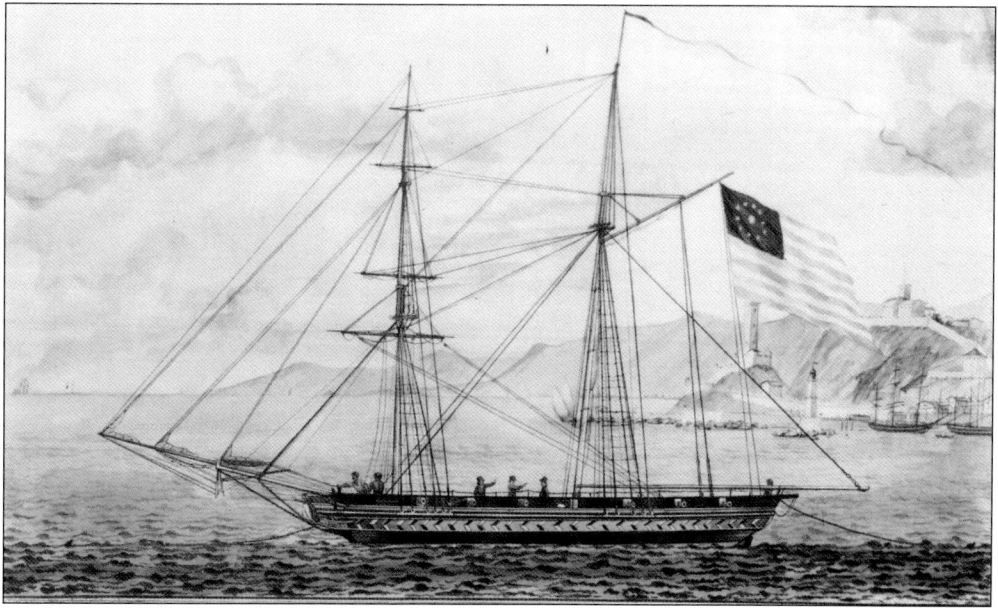

Even the earliest photographers were eager to capture Waimea Canyon's beauty. Often called the Grand Canyon of the Pacific, the colors are more vibrant, with greens and rust oranges, than its muted pink and lavender Arizona cousin. (Courtesy Kauai Museum.)

The people today who complain about the poorly maintained roads up to Waimea Canyon and Kokee State Park will appreciate this photograph of one of the really early roads to the canyon. Construction began in 1927 on a paved road to the canyon. (Courtesy Kauai Museum.)

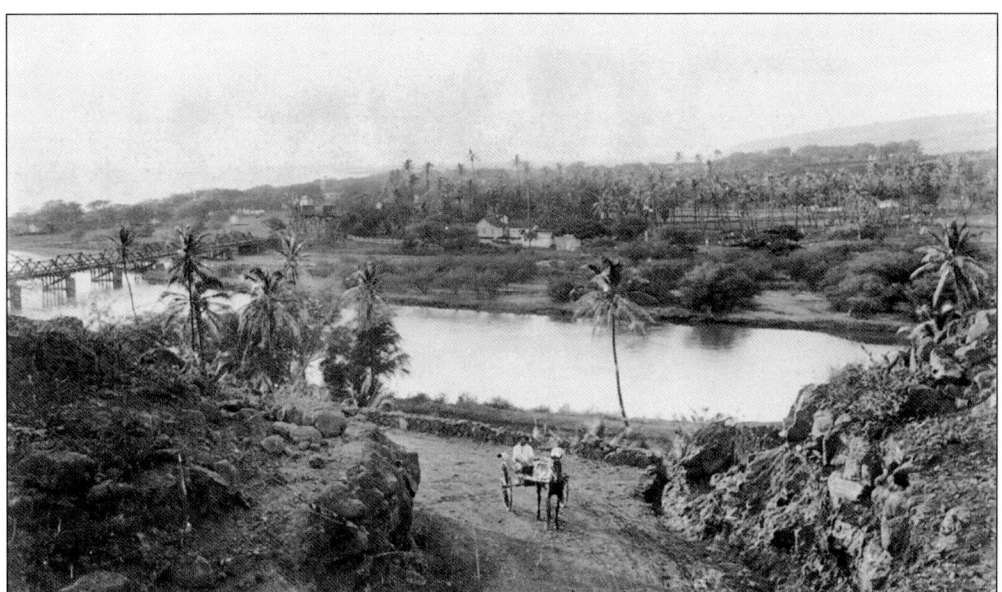

Theodore Severin took this photograph some time between 1890 and his death in 1898. It shows an early bridge across the Waimea River in the background. The pili grass huts of the 1840s have been replaced with wood. (Courtesy Kauai Museum.)

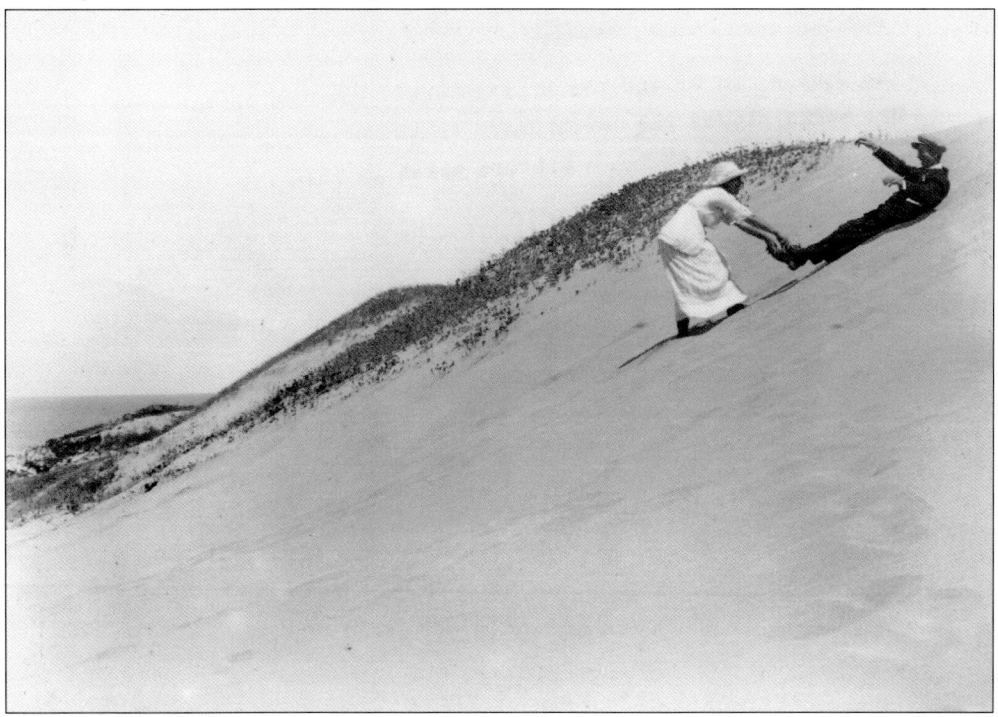

Ray Jerome Baker, exploring the famous "barking sands" that make their sound due to the shearing of the sand when it is compressed, is photographing Mr. and Mrs. Willis Marks, theater people from Los Angeles, in 1912. Mrs. Marks (Carol Marshall) had recently been in a theater production of *Bird of Paradise*, the first Hawaiian musical on Broadway, set in the 1890s. It featured the song "Aloha Oe," hula, and slack key guitar. (Courtesy Kauai Historical Society.)

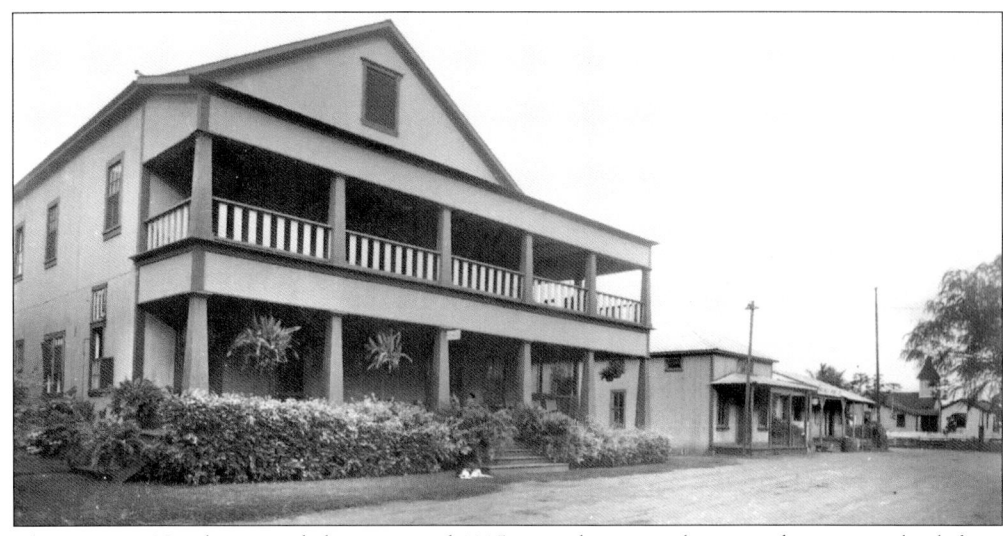

The Waimea Hotel, pictured above around 1915, was where travelers stayed one street back from the beach. The building no longer exists, but its location is known because the steeple of the Waimea Hawaiian Church can be seen in the far right of the photograph. On August 18, 1928, Waimea celebrated the Cook Sesquicentennial, marking the 150th anniversary of Cook's landing in Waimea, with the unveiling of the lava rock monument below designed by Hart Wood. Today a statue of Captain Cook stands next to the monument. It is one of two castings made in 1978 of the original one in Whitby, England, Captain Cook's birthplace. It was a joint sister-cities project with Vancouver, British Columbia; Whitby, England; and Waimea. It was also part of the State Foundation on Culture and the Arts project Art in Public Places. The statue was not moved from Waimea Canyon School to the Hofgaard Park location until 1987. (Both courtesy Kauai Historical Society.)

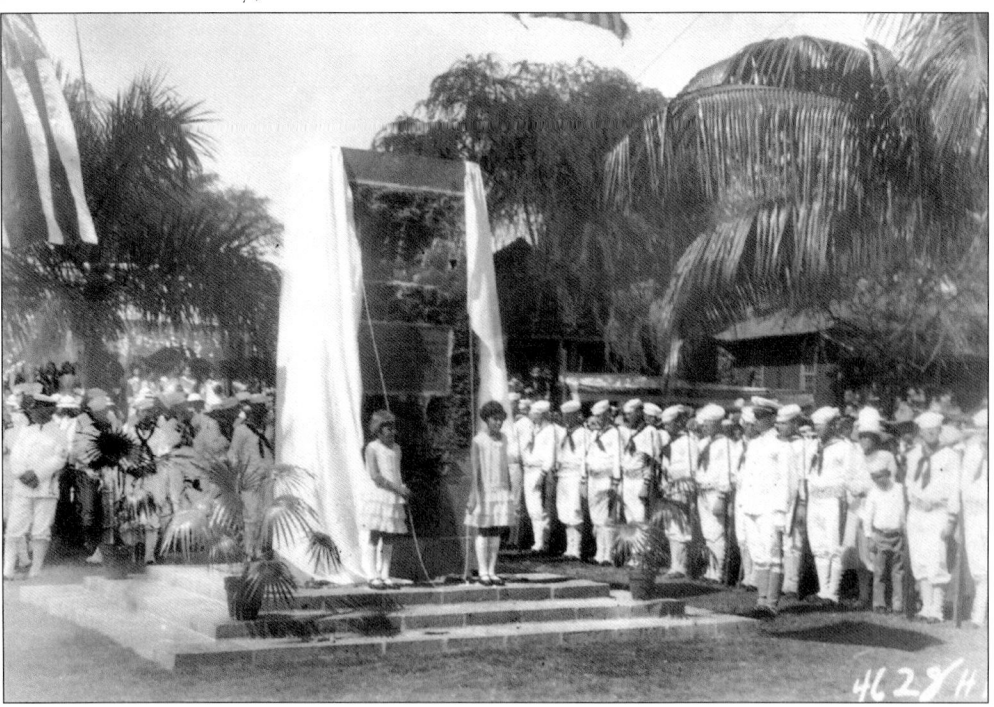

# Two

# HANAPEPE

*Hanapepe*, which means "crushed bay," is still within the Kona Moku. According to some, the place gets its name from the appearance of the cliffs as seen from the ocean. However, in oral communications between Gabriel I and Ilei Beniamina with Fredrick Wichman for his book, *Kauai, Ancient Place Names and Their Stories*, they believe the correct name is *Hanapepehi*, which means "killing bay." Hiram Bingham in his book, *A Residence of Twenty-One Years in the Sandwich Islands*, recounts the battle of August 1824 played out on the *Eleele* (black) plains of Hanapepe. King Kaumualii's son, George Humehume, led the battle with Kauai chiefs loyal to the Kaumualiis. They defended Kauai with wooden war clubs, spears, daggers, and slings, while the superior forces of Kamehameha fought with rifles and cannons. Amnesty was delayed by two weeks, thus allowing the killing of men, women, and children to continue. To add to the insult, burials were not allowed. The bodies were left to rot where they fell. It was so horrific that it was written about by many of the missionaries in their journals.

    The Hanapepe River is the third longest on the island. It stretches from the steep slopes of Mount Kawaikini, the highest point on the island at 5,243 feet, down to the sea. The valley is so long that the ancient Hawaiians gave it several names as the need to describe it changed. At the point where the name changes to Koula (red sugarcane), there is perhaps the most breathtaking waterfall on the island, Manawaiopuna (stream branch of Puna). At one time, it was a tourist destination not to be missed. Today it is unreachable, but it can be seen from the air on helicopter rides.

    Hanapepe did not begin as a plantation town, as some others did. From the mid- to late 1800s, Hanapepe had Hawaiians raising taro and Chinese immigrants raising rice. It could be quite a rowdy place with bars and opium dens. To some, the attitude and the buildings resembled a frontier town. Hanapepe was once a thriving town that had port facilities nearby to ship out bulk sugar and an airstrip for the first interisland air service in 1929. Most buildings seen today are of pre-war 1920 and 1930s vintage.

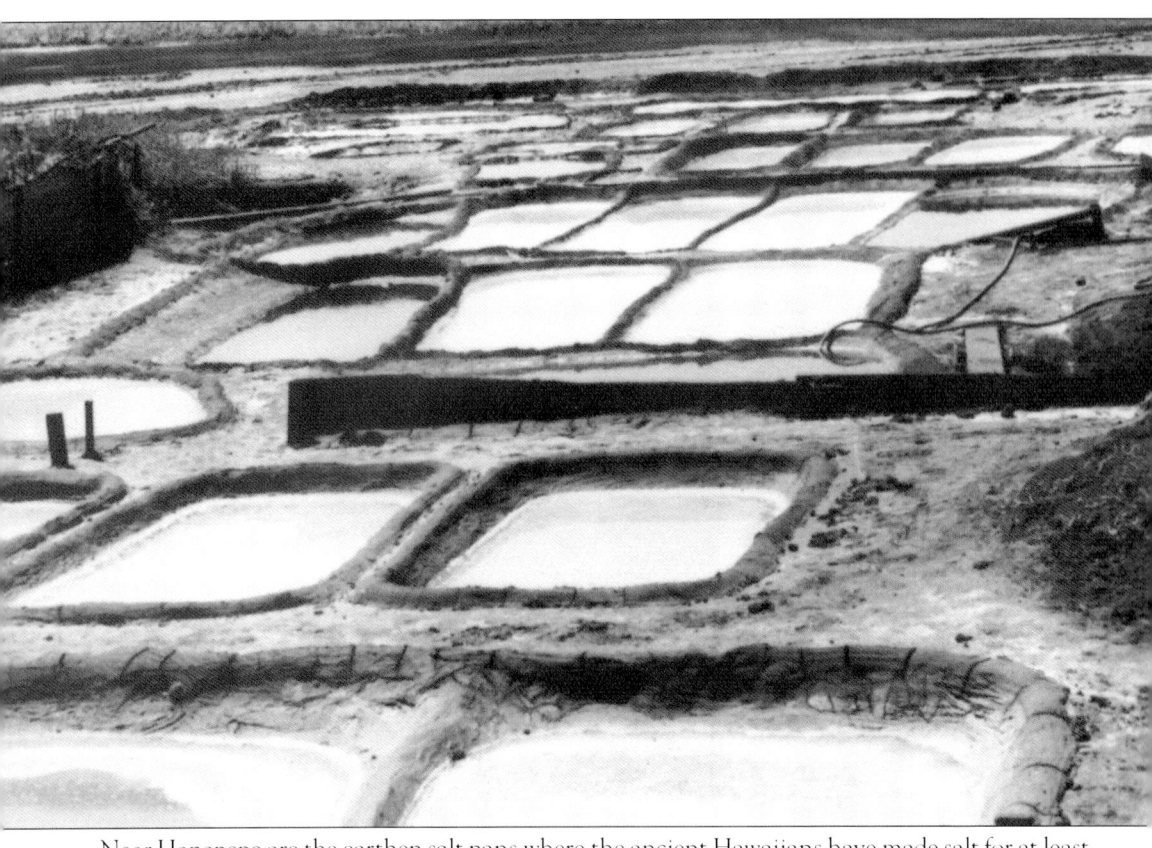

Near Hanapepe are the earthen salt pans where the ancient Hawaiians have made salt for at least 1,000 years. It is an art that has been preserved by families descended from ancient salt makers. *Paakai* means "salt." The water is tunneled from the ocean into the wells rather than taken directly from the sea. This is thought to be the only place in the world where salt is created using this method. Salt making is a summer activity, when the sun is hot and the water evaporates quickly. The process usually takes two to three weeks. Salt was an important trading commodity but never plentiful enough to become a major one. (Courtesy Kauai Historical Society.)

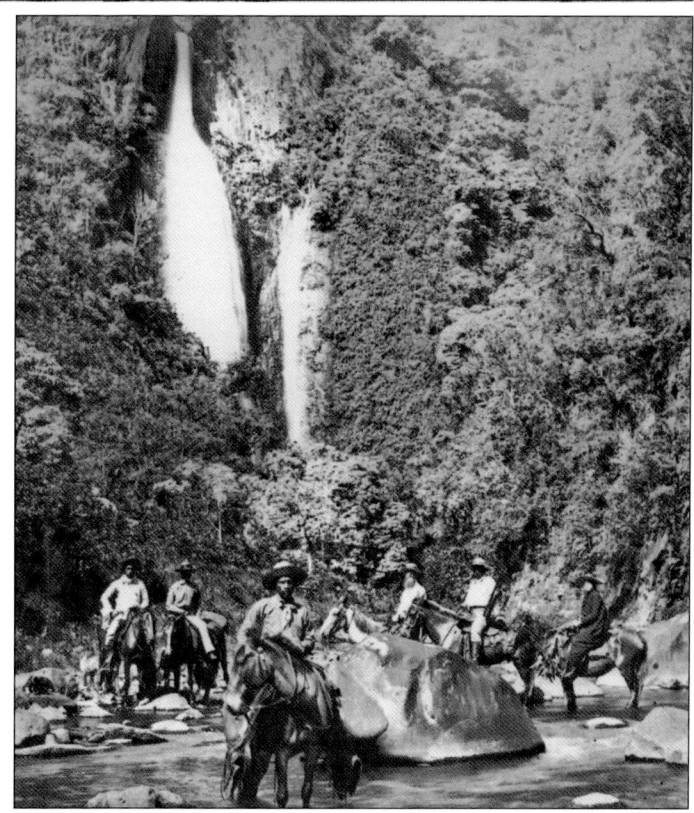

This photograph of Hanapepe dates back to the mid- to late 1880s. Everything to the left of the houses is rice paddies. Today's highway runs through the center middle of the photograph, where the wooden trestle bridge is, and through the rice paddies. Where Koula Street, the post office, and the library are today were all rice paddies. (Courtesy Kauai Museum.)

This photograph of Hanapepe Falls was taken in 1916. These unidentified horseback riders enjoy a scenic ride to a popular falls of the period. The Hawaiian name for this waterfall is Manawaiopuna. (Courtesy Kauai Museum.)

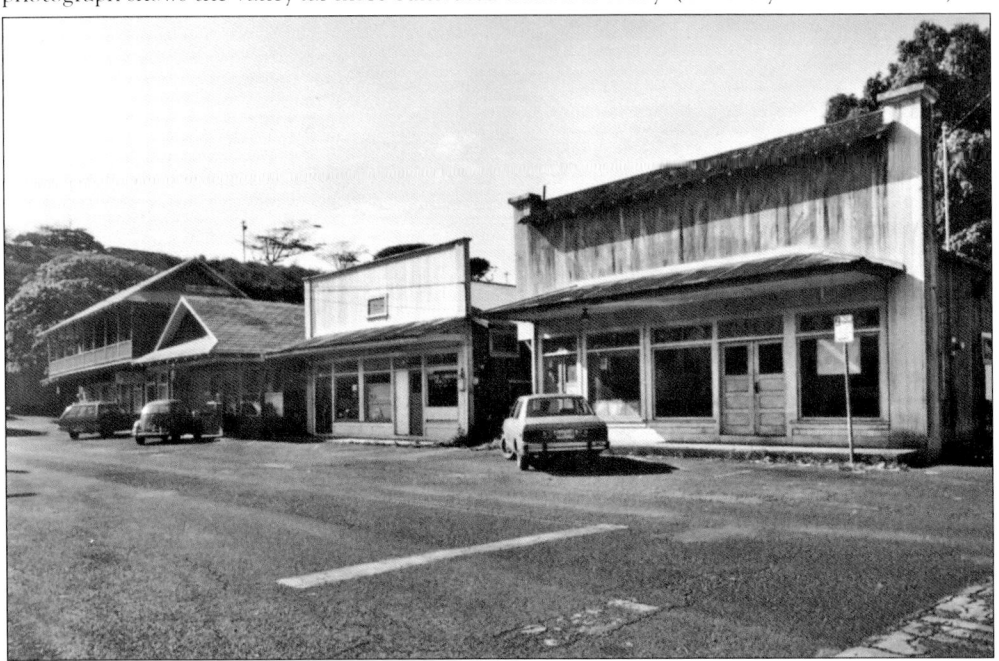

The Hanapepe Valley Overlook is a popular turnout on Kaumualii Highway. People often ask, "What am I looking at?" or "What am I looking for?" These are honest questions. This 1930s photograph shows the valley far more cultivated than it is today. (Courtesy Kauai Museum.)

This photograph is from the T. K. Kunichika Collection, showing the western-style buildings popular in Hanapepe. The Senkawa Hotel, the Kawamura Fish Market, and the Ozuka Laundry were just some of the services available in the 1920s. (Courtesy Kauai Historical Society.)

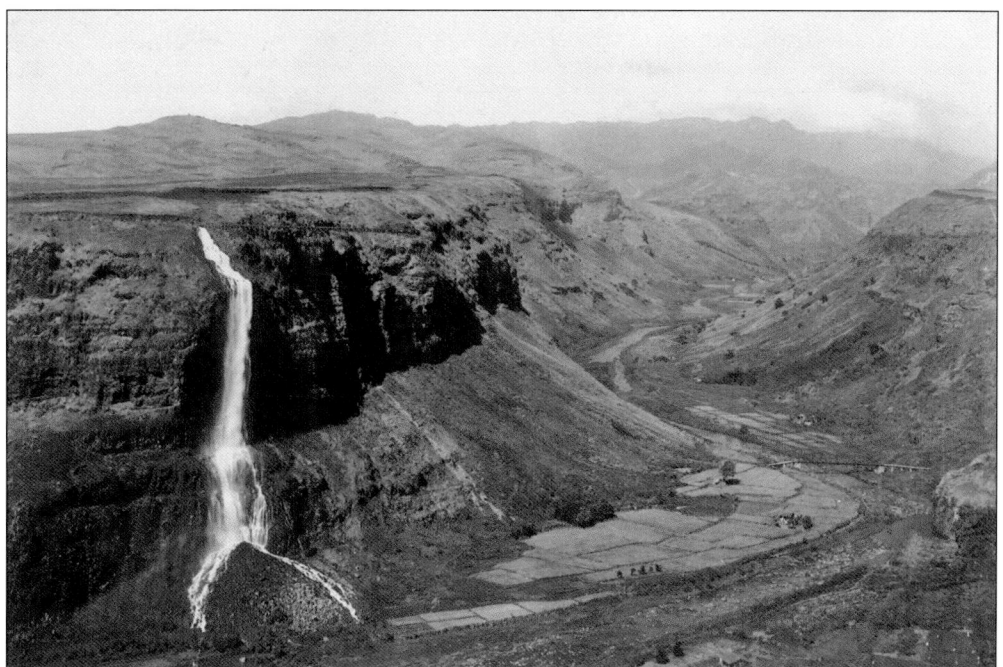

On occasion, the Hanapepe Valley Overlook could be much more spectacular. In days gone by, when the McBryde Sugar Company needed to release an abundance of water from the irrigation flumes, this waterfall would appear. (Courtesy Kauai Museum.)

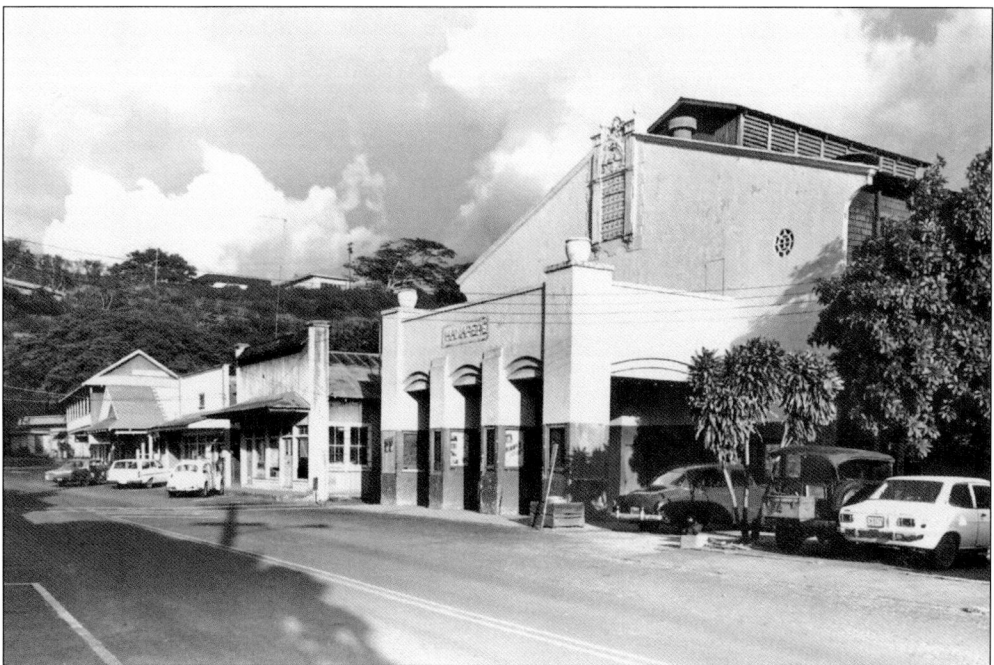

In 1976, John Wehrheim took this street scene looking toward the bluff and Eleele School. The big cement building was the Hanapepe Theater, typical of theaters constructed in the 1930s. The theater was built in 1932 and was the first "talking picture" theater in the town. (Courtesy Kauai Historical Society.)

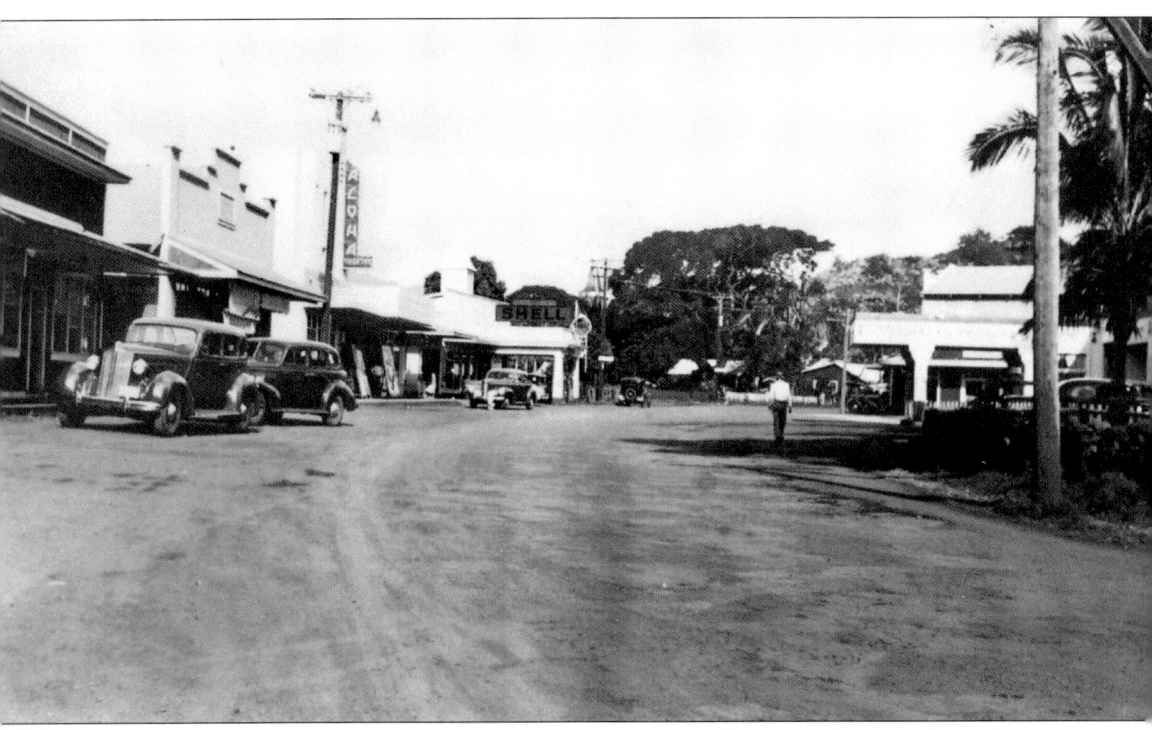

This is the view when driving through Hanapepe from the Westside about 1934. By that time, the San Ke Heong Chinese restaurant had been built as well as the Ozaki Store, which was a department store that had dry-cleaning, laundry, barber, shoes, clothing, and jewelry. Many of the buildings seen in this photograph are still standing. Note that another theater has been built, the Aloha. Today the building next to the theater and closer to the viewer is the Talk Story bookstore. There were competing gas stations across from one another. The tall building behind the Standard Oil station is the Storybook Theater, now home to Russell the Rooster, a local children's TV favorite. (Courtesy Kauai Historical Society.)

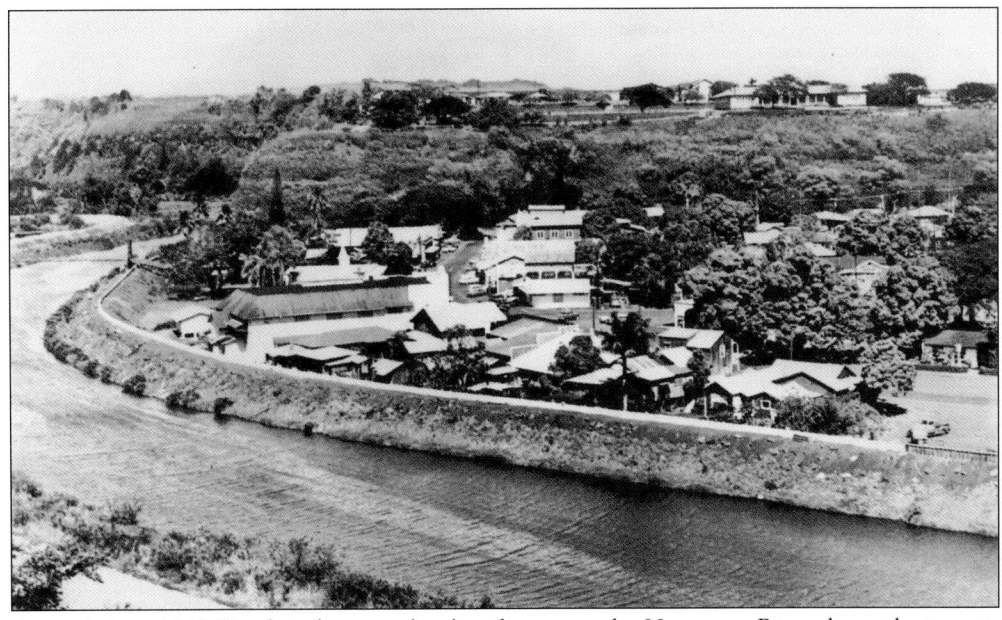

Photographer John Wehrheim took this view of Hanapepe also coming from the west side. By 1976, the Standard station had moved across and down the street, closer to the viewer. The buildings on both sides of the gas station no longer exist. (Courtesy Kauai Historical Society.)

Around the mid-1900s, this photograph taken from near the Hanapepe River shows the town is much more built up. Koula Street is there. Eleele School is up on the bluff to the right, and the swinging bridge over the river is visible in the center left. (Courtesy Kauai Museum.)

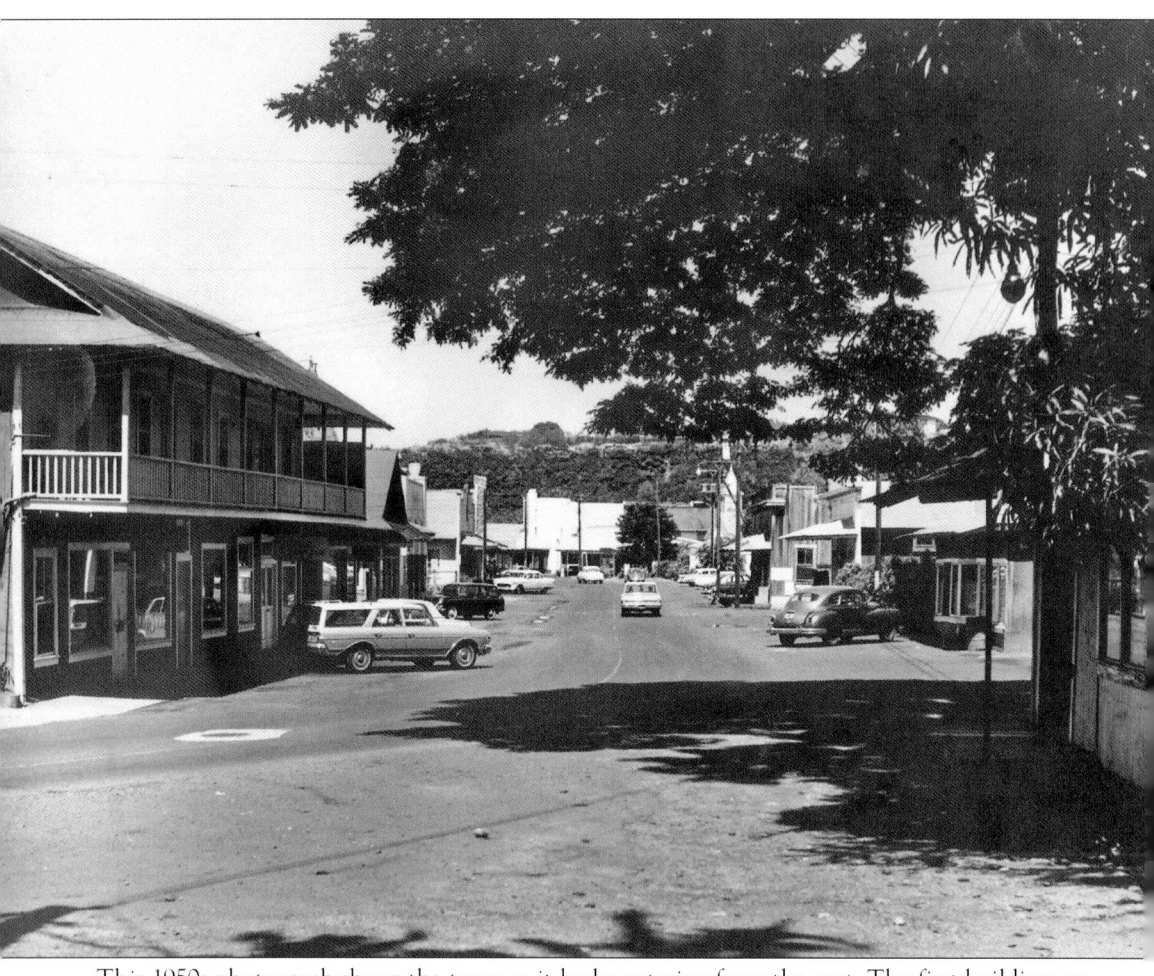

This 1950s photograph shows the town as it looks entering from the east. The first building on the left was made famous by the production company that came to Kauai to film *Thornbirds* with Richard Chamberlain and Barbara Stanwyck in 1983. This building was renovated and used as the hotel where Rachel Ward and Bryan Brown go on their honeymoon. This area was transformed into Queensland, Australia. Today it has transformed into a little artist colony that is quite lively on Friday nights. (Courtesy Kauai Historical Society.)

# *Three*

# Missionaries and the Port of Koloa

On October 23, 1819, a group of missionaries from Boston, Massachusetts, set sail aboard the *Thaddeus* destined for the Sandwich Islands. These missionaries were part of a religious revival that began in England in the 1700s, establishing missions across the South Pacific. The American Board of Commissioners for Foreign Missions (ABCFM) was organized in 1810 to go out into the world and spread the gospel. Whalers brought back tales about exotic heathens in the Sandwich Islands. It was not until the missionaries met an "exotic heathen" name named Henry Opukahaia, known as "Obookiah," that there was serious consideration. Opukahaia was from the island of Hawaii. Tired of constant war, Henry chose to go to sea on a whaling ship, ending up in Boston. He became a Christian convert. He wished to return to Hawaii and share Christianity with his countrymen, but Henry died of typhus in 1818. Stories circulated about this young man's unfulfilled wish. Finally, the ABCFM had a cause to rally behind.

Aboard that very first ship were Hiram and Sybil Bingham, Samuel and Mercy Whitney, and Samuel and Nancy Ruggles, along with four Hawaiian youths. One was Prince George Kaumualii, who wished to return to Kauai. The missionaries arrived in Kailua on April 4, 1820. Liholiho gave provisional approval to stay for one year. He had been advised that the English might not approve of the presence of so many Americans. Hiram Bingham, the leader of the group, stayed in Honolulu to set up the mission headquarters. Reverends Whitney and Ruggles accompanied the prince to Kauai. Upon arriving at Waimea, both the *Thaddeus* and the fort gave 20-gun salutes. Samuel Ruggles said it was a most touching scene between father and son as they embraced and touched nose to nose.

The Koloa mission grew as the port of Koloa grew. Once a sleepy fishing village, Koloa expanded with whaling and the sandalwood trade. Waimea remained the capital of Kauai, but Koloa became its economic center. Governor Kaikioewa leased land to Ladd and Company for the purpose of growing sugarcane commercially in 1835. It was the first one in the kingdom.

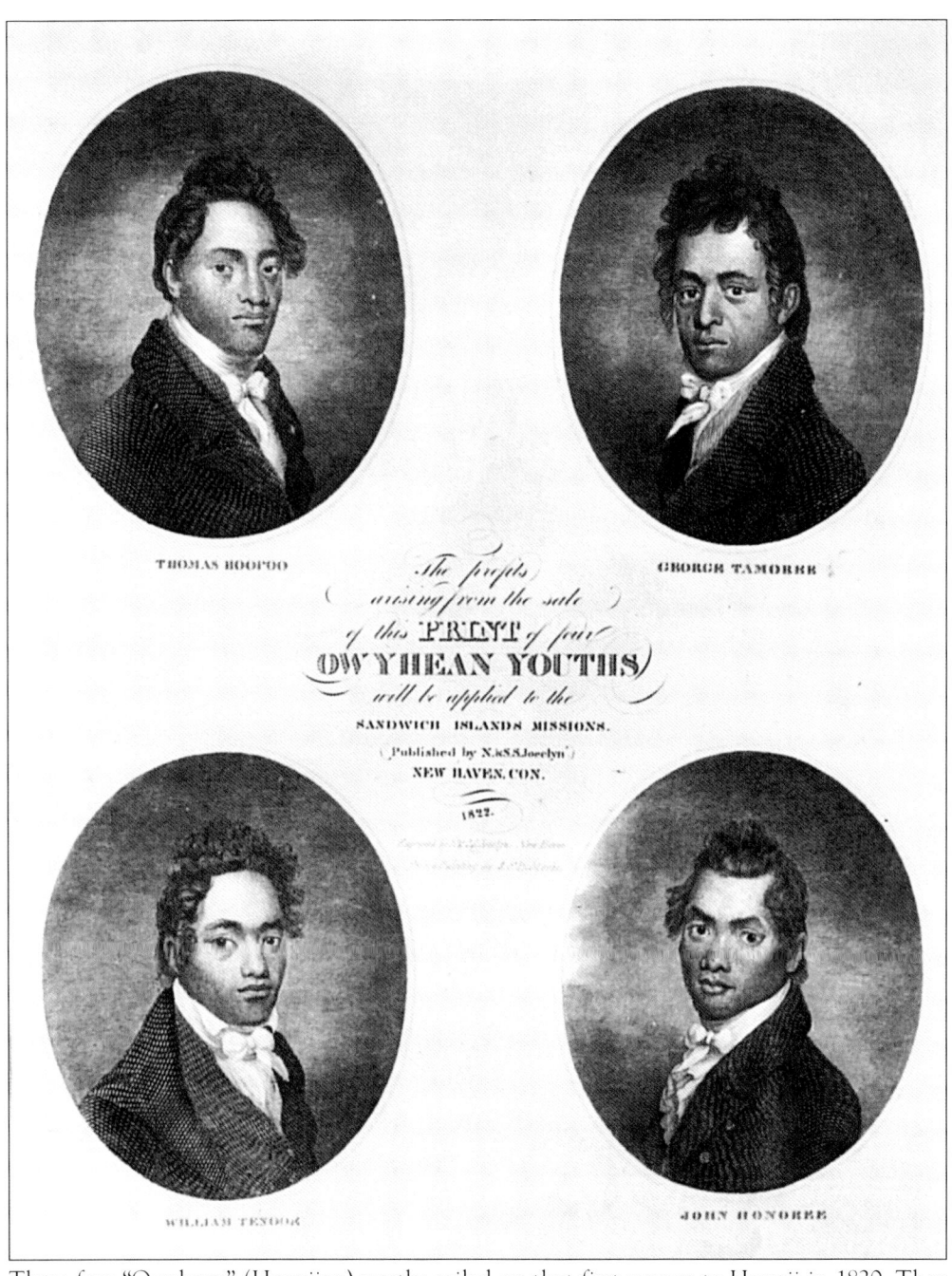

These four "Owyhean" (Hawaiian) youths sailed on that first voyage to Hawaii in 1820. They were listed on the manifest as interpreters. Their names were Thomas Hopu, William Kanui, John Honolii, and George Kaumualii. The one in the top right is George Humehume Kaumualii, son of Kauai's king. He had been sent 10 years before to America to learn. Unfortunately, he learned from the school of hard knocks. The handsomely paid captain took the king's money but did not pay for schooling. George fought in the war of 1812 for America. (Courtesy Mission Houses Museum Library.)

Just five months after arriving, Maria Kapule Whitney was born on Kauai on October 19, 1820. Maria was the first white child born on Kauai and was named for Kauai's queen, Kapule, wife of King Kaumualii. She married Rev. John F. Pogue in 1848, after he had joined the mission station in Koloa in 1844. He transferred to Kaawaloa on the Big Island after their marriage. (Courtesy Mission Houses Museum Library.)

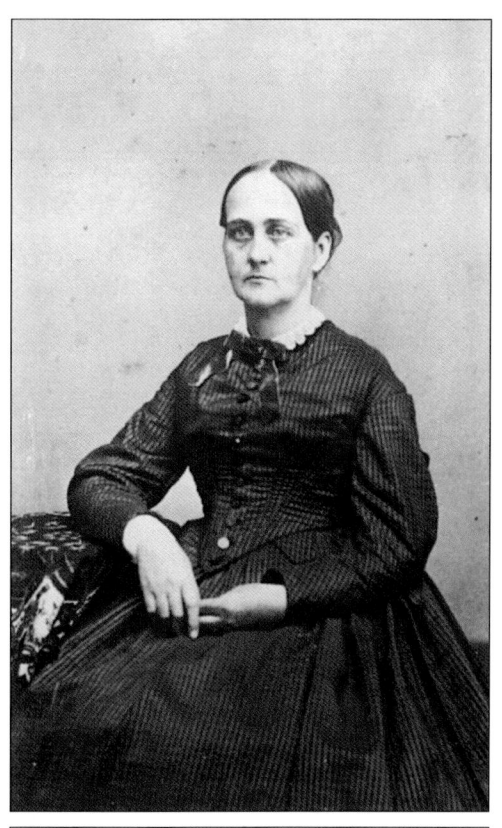

Samuel Ruggles's journal entry said that King Kaumualii wanted the missionaries to stay. He would build schools and a large meetinghouse. Ruggles and wife, Nancy (below), were thrilled the king and queen wanted to learn to read. By April 1821, good to the king's word, the Whitneys and Ruggles moved into a spacious building 54 feet long and 25 feet wide with a wood floor, glass windows, and five bedrooms. There were extra large rooms for worship and classrooms. Soon after, the king was kidnapped. By 1822, the Ruggles moved to Hanapepe. (Both courtesy Mission Houses Museum Library.)

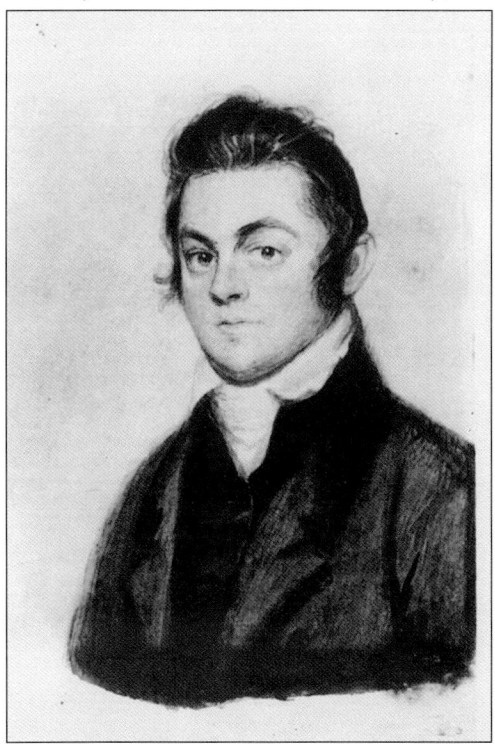
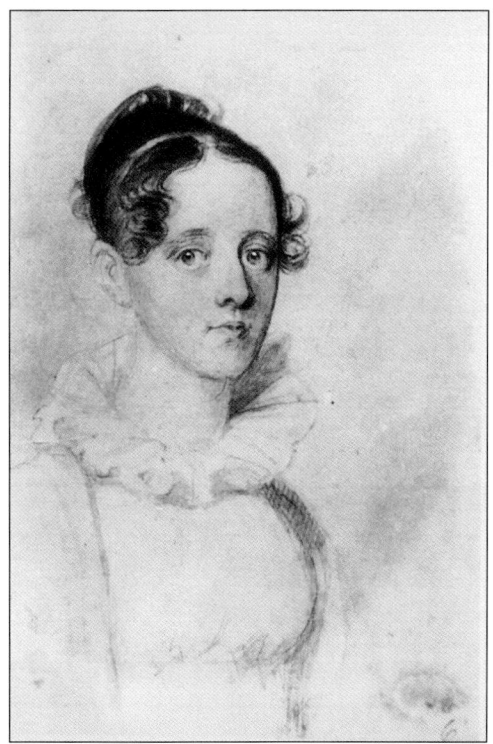

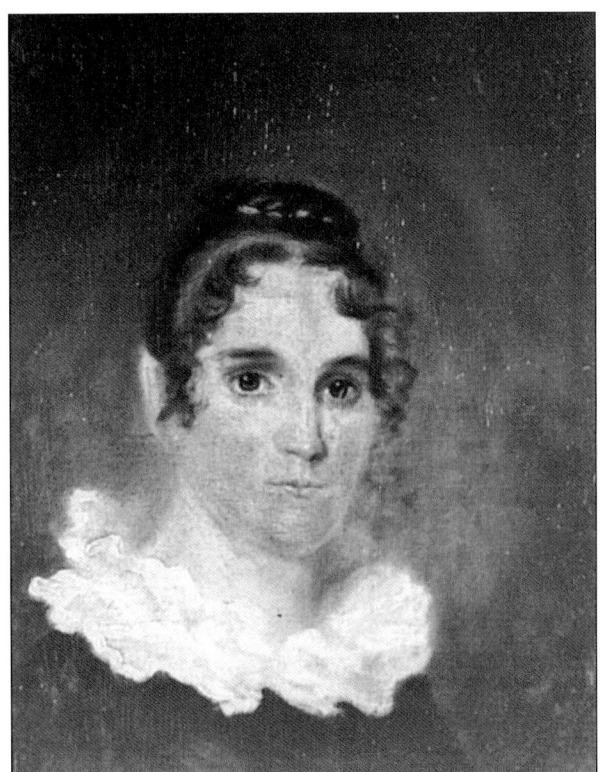

Mercy Partridge Whitney felt fortunate that even with the king's removal, his wishes were carried out. By 1829, they were living in an even nicer, two-story stone house away from the river, closer to the new church, and a quarter-mile from the ocean. (Courtesy Mission Houses Museum Library.)

This painting of Whitney and that of his wife were painted in 1819 by Samuel Morse, the inventor of the telegraph and Morse code. Samuel Whitney's journal has been an invaluable resource regarding the history of Kauai from his arrival in 1820 until his death in 1845. Whitney translated a number of books into Hawaiian between 1832 and 1836. (Courtesy Mission Houses Museum Library.)

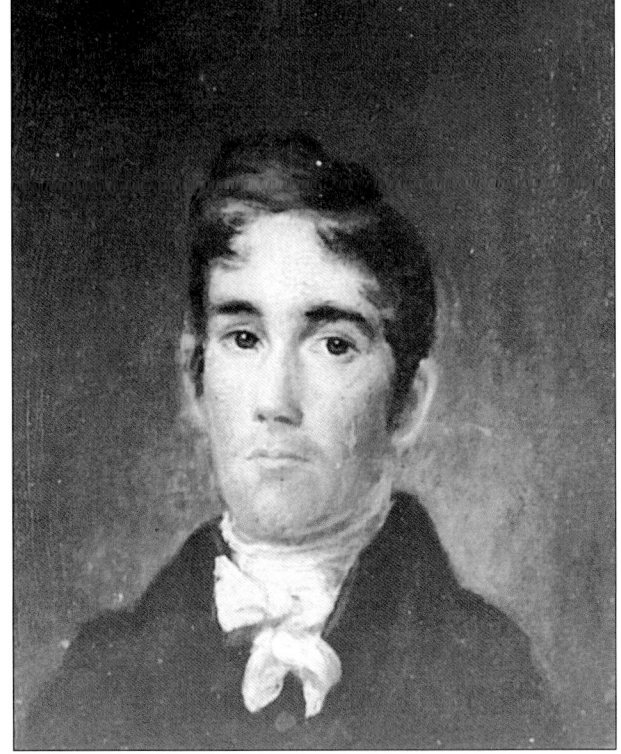

In 1828, Rev. Peter J. Gulick and wife Fanny arrived in Waimea. A house with a board floor was uncommon. Reverend Gulick and Reverend Whitney made a preaching tour of Kauai in the company of Governor Kaikioewa. In 1834, they moved to Koloa to start a second mission. In two years, they went from 12 to 125 members. Services were held in pili grass houses until a wooden meetinghouse was built in 1837. (Courtesy Mission Houses Museum Library.)

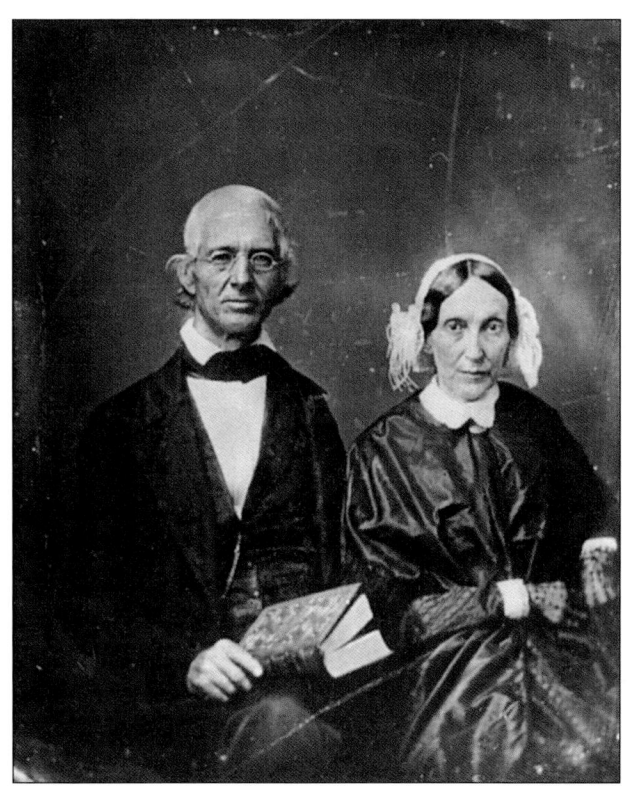

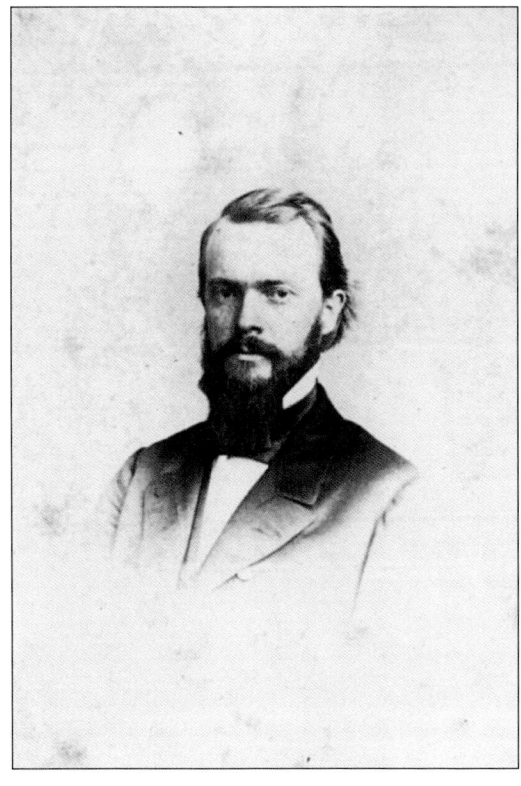

In July 1828, Mrs. Fanny Gulick had a son, Luther Halsey Gulick. Deborah Kapule, former queen of Kauai, sent 63 oranges as a gift. Oranges were highly prized. Luther was a missionary here in Hawaii. In 1861, he founded *Ka Nupepa Kuokoa*, the longest running and most influential Hawaiian-language newspaper. His son, also named Luther, is in the Basketball Hall of Fame, invented the Spirit-Mind-Body Triangle symbol for the YMCA, and founded the Campfire Girls with his wife. (Courtesy Mission Houses Museum Library.)

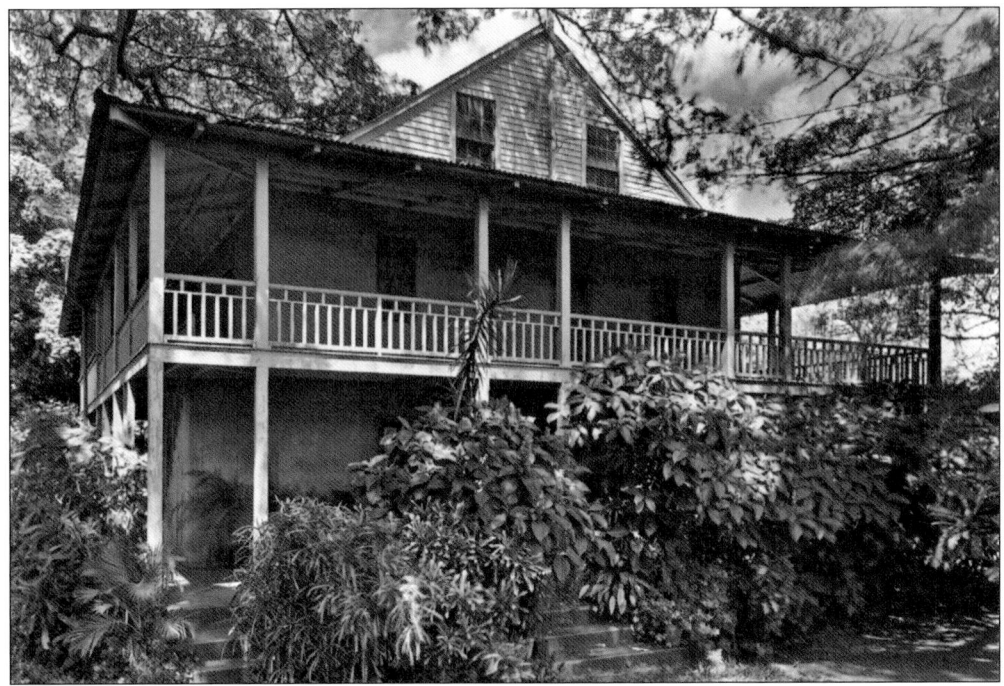

The Gulick-Rowell house is the only missionary house still standing in Waimea. The Gulick family lived in it from about 1829 until 1834, when they were transferred to the Koloa mission. Fifteen years later, Rev. George Rowell rebuilt it in 1846 when he was sent to replace Samuel Whitney after his death in 1845. It has been renovated once since. It is still a private home today. (Courtesy Kauai Historical Society.)

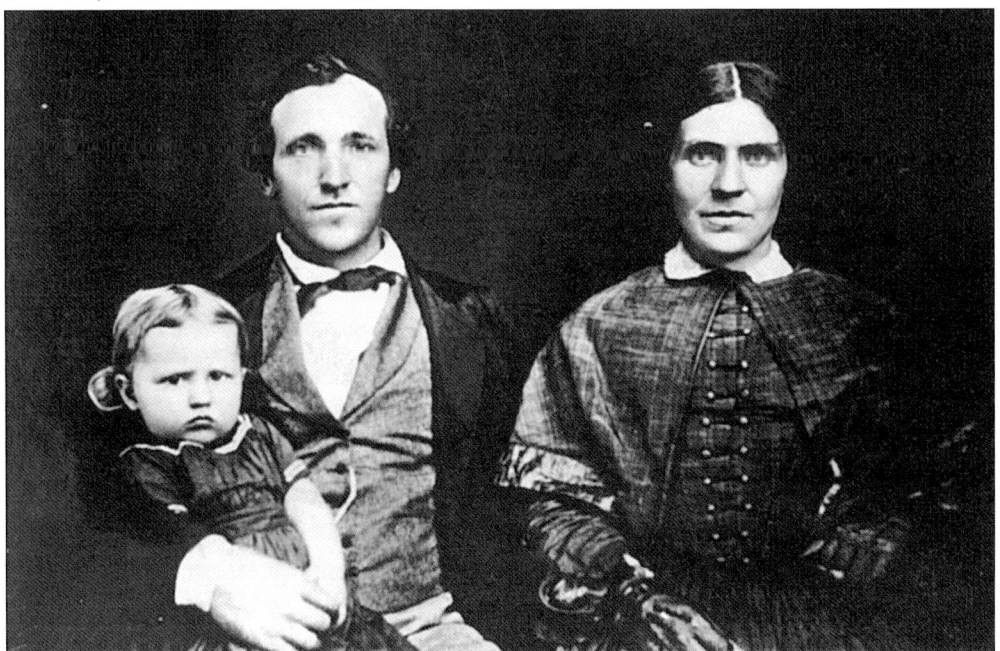

George Rowell, shown here with wife Malvina and daughter Mary Adelaide, moved into the house once occupied by the Gulicks. (Courtesy Mission Houses Museum Library.)

When the mission's church collapsed in 1847, Reverend Rowell became both architect and building supervisor. The new church was constructed of coral blocks 30 inches long, 118 inches wide, and 6 to 8 inches thick quarried from a limestone ledge a mile away. Deborah Kapule helped the construction by lending a pair of oxen to drag the heavy coral blocks to the church building site. It was complete in 1858. It is the Waimea United Church of Christ today. (Courtesy Gaetano Vasta.)

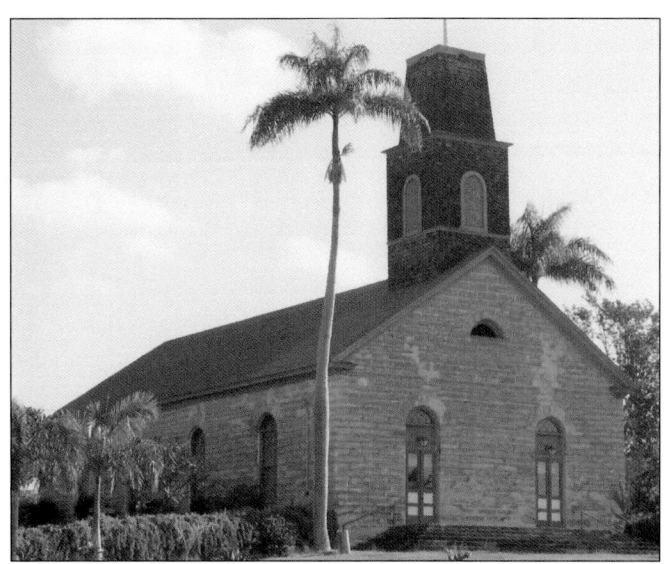

In 1864, Reverend Rowell was brought up before the church board regarding how he allowed membership without baptism, among other charges of misconduct. His church superiors dismissed him. However, his loyal native Hawaiians wanted him to remain as pastor. Due to his excellent command of the Hawaiian language, his understanding, and his high regard for their culture and customs, they followed him to what is known today as the Waimea Hawaiian Church. (Courtesy Kauai Historical Society.)

35

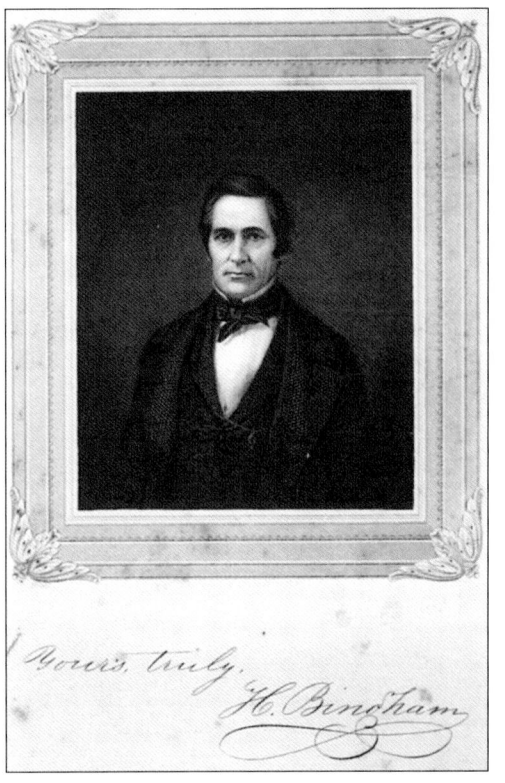

Hiram Bingham (1789–1869), pictured at left, was on a preaching tour of the island in 1824, shortly before King Kaumualii died. Kaumualii had been living in exile on Oahu for three years. Bingham spoke to him just before coming to Kauai. Bingham writes: "We found Kaumualii seated at his desk, writing a letter of business. We were forcible and pleasantly struck with the dignity and gravity, courteousness, freedom and affection with which he rose and gave us his hand, his hearty aloha, and friendly parting smile, so much like a cultivated Christian brother." When the king died, Bingham said a gloom fell over Kauai. Hiram Bingham II (1831–1908), below right, was born in Honolulu, the sixth child. At age 10, he was sent to school in Massachusetts and graduated from Yale. He married Minerva Clarissa Brewster (1834–1903), below left, on November 18, 1856. He returned to Honolulu, where he translated the Bible into the language of the Gilbert Islands. He also authored a hymnbook. (All courtesy Mission Houses Museum Library.)

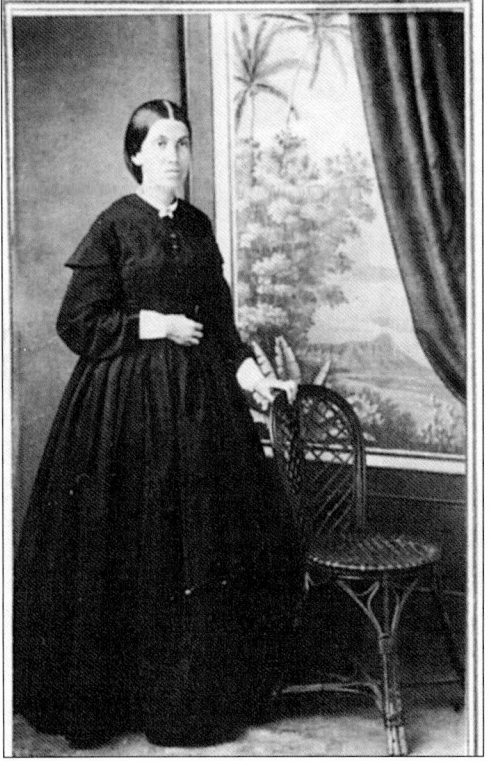

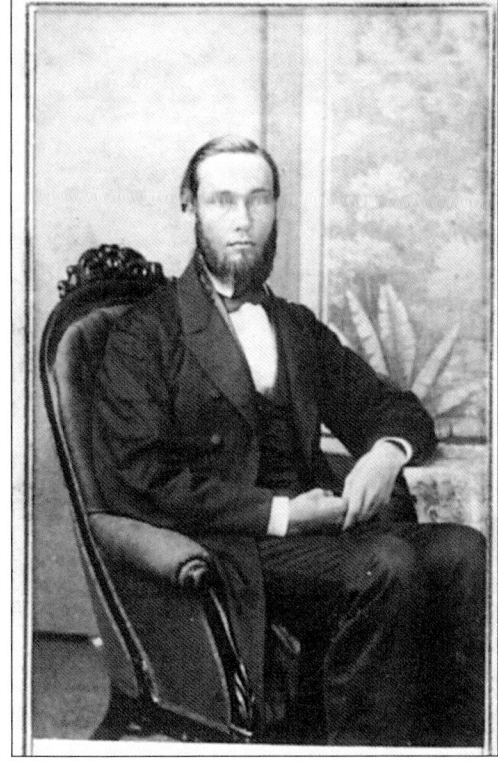

On Hiram Bingham's first visit to Hanalei, he made this sketch, entitled *A View from the Foothill at Hanalei, Kauai, 1821*. Hanalei was one of the main pre-contact villages on the island. Hawaiians, as a rule, did not bunch their huts together. They tended to spread them out, as is shown here, surrounding the bay with the majestic mountains dripping with waterfalls. Note the outrigger canoe in the bay. (Courtesy Kauai Museum.)

This 1920s photograph of Hanalei is taken from a similar vantage point as Bingham's sketch. It shows that Hanalei's majestic mountains are still a main focal point. At one time, half the rice grown in Hawaii came from Hanalei. (Courtesy Kauai Museum.)

Before the name Dole became synonymous with pineapple, it was known as the first school in Koloa. Daniel Dole (born 1808 in Maine), the first principal of Punahou School, left and moved to Kauai to start the Dole School, which later became Koloa School, the first public school on Kauai. He married Emily Hoyt Ballard (1807–1844). They had two sons. (Courtesy Mission Houses Museum Library.)

Charlotte Close Knapp Dole (born in 1813 in Connecticut) came with her husband, Horton Owen Knapp. After he died in 1845, she married Daniel Dole on June 22, 1846, in Honolulu. She was a Hebrew, Greek, and Latin scholar. She assisted her husband as principal at Punahou and at his school on Kauai. She died on July 5, 1874. (Courtesy Mission Houses Museum Library.)

No photographs exist of the Dole School, but it was a single clapboard room with a thatched roof. The school enlarged quickly, since many lived too far away to return home daily. Aubrey Robinson and Francis Gay came from Niihau; four Rowell children came from Waimea; Emily, William, and Maria Rice came from Lihue; and four others came from the north shore. Dole died in Kapaa in 1878 and is buried in the Lihue Cemetery. (Author's collection.)

In this early Koloa Mill photograph, one can see all the plantation housing provided for the workers. The small stand-alone buildings between the rows of houses are outhouses. (Courtesy Kauai Museum.)

This 1939 view of the Tunnel of Trees is part of *Maluhia* (peaceful) Road. Walter Duncan McBryde planted them as part of a community project in 1911. It is said he used the 500 leftover trees to landscape his estate at Kukuiolono. (Courtesy Kauai Museum.)

Before the eucalyptus trees had time to grow into a tunnel, this 1915 photograph shows there was an avenue of monkeypod trees on what would now be Poipu Road. Today there are just a few left. (Courtesy Child family.)

Maluhia Road, also known as Route 520, ends in Koloa. From there it is a short drive to Poipu Beach. Before the Kiahuna, Sheraton, and Waiohai Hotels, there was only the Knudsen residence at Poipu Beach in the 1920s. The Heiau Kiahuna was there before that, but it has disappeared with time. (Courtesy Kauai Museum.)

Spouting Horn has always been a tourist attraction. It is nothing more than a lava tube. A tube forms when an upper layer cools and creates an insulating area while the hot lava continues to flow below. Being next to the shore, wave action forces water back up the tube, creating a water geyser that is spectacular to watch but difficult to catch on film, particularly back in 1916, when this photograph was taken. (Courtesy Kauai Museum.)

As this photograph shows, in 1900 Boat Day at Koloa Landing was a bustle of activity for the community. Today unless one is a fisherman or scuba diver, the average person does not even know this former center of commerce exists. (Courtesy Kauai Museum.)

Being an island community has never stopped progress from arriving on Kauai. This photograph taken from a local family's 1916 album shows an automobile being off-loaded at Koloa Landing. (Courtesy Kauai Museum.)

As the three sailing ships above suggest, Koloa Landing was a thriving port from the 1840s to 1870s. Sheltered from strong winter trade winds, Koloa was a favored port of call for sweet potatoes, beef, pigs, and firewood. The missionaries opened their second station there in 1834, and Ladd and Company started the first sugar plantation in 1835. Koloa was a busy port with traders and whalers. Many journals and books from this time mention landing at Koloa, such as Isabella Bird's book *Six Months in the Sandwich Islands*. Below, interisland steamers took over as the primary mode of transportation. In this photograph from the 1900s, Koloa is still a busy port, but sails have been replaced with steam. They still required rowboats to off-load the cargo. It was just such a steamer that brought author Jack London to Kauai in May 1915. (Both courtesy Kauai Museum.)

Prince Jonah Kuhio Kalanianaole was the designated heir to the throne of the Hawaiian kingdom. Instead of being a king of a kingdom, he became a delegate to Congress from 1903 to 1922. He was a tireless worker for Native Hawaiian rights and the spearhead for the Hawaiian Home Commission Act of 1921. He was so beloved that his birthday, March 26, has been a holiday since 1949. (Courtesy Kauai Museum.)

This 1924 photograph was taken at the unveiling of a monument to commemorate the life of Prince Jonah Kuhio Kalanianaole. This monument stands near where he was born in Kukuiula in 1871. On this 3-acre property is an ancient fishpond, and to the back on the left side is the Heiau Hoai. (Courtesy Kauai Museum.)

# Four

# Sugar, Pineapple, and Rice

The first sugarcane mill was on Kauai when Hawaii was a kingdom. Sugar was king for over 150 years. Sugar started on Kauai in 1835, but although there is still some sugar production on the west side, sugar has been dethroned. At various times, there were 10 different companies: Kekaha, Gay and Robinson, Olokele, McBryde, Koloa, Kipu, Grove Farm, Lihue, Kealia (Makee), and Kilauea. Kipu was the last to be established in 1907 and first to close in 1942. It went into ranching. The Theo H. Davis Company established McBryde Plantation in 1899. It was named McBryde due to the fact that most of the land was owned by the McBryde family, though they were not involved with the plantation. This plantation closed in September 1996. The last to close were Kekaha Sugar and Lihue Plantation. They both closed in 2000. Today only Gay and Robinson's Olokele lands are still in sugarcane production. The company was originally established in 1889 as a partnership between Eliza Sinclair and her two grandsons, Aubrey Robinson and Francis Gay.

Pineapple was first introduced to Hawaii in 1813. The climate and rich soil made it a perfect fit. At one time, canned pineapple was the territory of Hawaii's second industry. Practically all of it was grown in the islands. The beauty of growing pineapple was that the fields could be full and all the majestic views were still visible. Kauai had three large pineapple canneries. Two canneries were on the east side in Kapaa, anchored by the largest pineapple fields on Kauai. The other cannery was on the west side in Lawai, near the Kalaheo fields. The pineapple industry declined steadily in the 1960s with the closing of all three canneries by the end of that decade.

Rice was grown in many of Kauai's towns, such as Waimea, Hanapepe, Lihue, Kapaia, Kealia, and Hanalei. Rice production began as early as the 1850s and was an established crop by the 1860s. Rice ended in Hawaii in the 1960s after the islands had been a major producer for 100 years.

Capt. James Makee chartered Makee Sugar Company in 1877. Makee, King David Kalakaua, and a *hui* (group) of others purchased the Ernest Krull Sugar Estate. Due to several reasons—among them the death of Makee in 1878—his son-in-law, Col. Zephaniah S. Spalding, purchased the majority interest in the company and took over its management. By 1881, the Hui Kawaihau was dissolved. Note the "Sleeping Giant" Mountain in the background at left. (Courtesy Kauai Museum.)

Note the unidentified man standing on the mountains of sugar bags ready for shipment in the early 1900s. Colonel Spalding was the first to introduce night manufacture in Hawaii. The factory and the fields had lights for night harvesting. Using this method, Makee Sugar was able to handle 400 tons of sugarcane in a 24-hour period. (Courtesy Kauai Museum.)

It is unknown what celebration was being observed when Henry Funk photographed this band parading about the Makee Sugar Mill. A windmill is clearly visible in the background. It is interesting to note that in 1880, the annual fuel consumption at the mill consisted of 244 tons of coal and 250 cords of firewood. This photograph was taken around 1900. (Courtesy Kauai Museum.)

While out surveying the Makee sugar lands south of Kealia around 1900, photographer and engineer Henry Funk set up this shot of the survey crew with the Anahola or Kalalea, meaning "prominent" or "protruding," Mountains centered right between the cut. Today that landscape is known as King Kong's Profile. (Courtesy Kauai Museum.)

Col. Z. Spalding, pictured in 1877, was the son of Rufus Paine Spalding, a U.S. congressman from Ohio. Spalding, named after his mother's father, Judge Zephaniah Swift, proved himself a distinguished leader in the Civil War as a major and later a lieutenant colonel in the Union army. He was an appointee of Pres. Andrew Johnson to the American consulate in Honolulu until 1869. (Courtesy Kauai Historical Society.)

This Spalding family photograph was taken in the late 1800s. The colonel had three daughters who each married European noblemen. His son James liked playing polo and built a polo field inside his father's Waipouli racetrack in 1915. (Courtesy Kauai Historical Society.)

Valley House, home of Zephaniah Spalding, was built in 1885 in the finest Victorian tradition. It had a large central staircase and the finest furnishings from Europe. This view from across the lily pond shows some of the royal palms that lined the courtly entrance to the 90-acre estate. King Kalakaua liked to visit often. This photograph was taken in 1920. (Courtesy Kauai Historical Society.)

Valley House has had several incarnations. At one time, it was a fashionable hotel. Later, in 1946, it was the 200-capacity boy's camp named Camp Hawaii Nei. It burned to the ground in 1950. Steven Spielberg built the Jurassic Park Visitor Center there in August 1992. (Courtesy Kauai Historical Society.)

This Senda photograph shows the flumes heading towards the mill. By 1910, Lihue Plantation's irrigation system had grown to include 33 miles of ditches, 4 miles of tunnels, and 9,900 feet of water gearing flumes. When it closed, factory manager Alan Muraoka was quoted as saying, "Whoever put this place together was a mechanical genius. Everything is linked together for maximum efficiency. For example, the bagasse, the fiber left over after the cane has been shredded, fuels the boiler that makes the steam that turns the turbines that makes the electricity that powers the machinery. Then the same steam is routed and rerouted to heat the syrup that is boiled to make the sugar." (Courtesy Kauai Museum.)

Before 1891, Lihue Plantation used oxcarts to deliver the harvested sugarcane to the mill. After 1891, the Lihue Plantation used railroad cars to deliver cane to the mill. That gave the plantation the ability to expand. In 1910, it bought controlling interests in Makee Sugar, and in 1916, it purchased the 6,000-acre Princeville Plantation. (Courtesy Kauai Museum.)

This photograph was taken of the Ahukini Landing by Theodore Severin around 1890. The sugarcane train is waiting for the sugar bags to be off-loaded and sent to some foreign port. (Courtesy Kauai Museum.)

According to Ray Jerome Baker's diary, he took this photograph on April 19, 1960, after a visit with Gaylord Wilcox at his home, Kilohana. Designed by architect Mark Potter using an English country theme, it was built in 1937. It was a private home until the mid-1970s. Today visitors to Kilohana have lunch at Gaylord's restaurant. Wilcox had been plantation manager for Grove Farm Plantation. (Courtesy Kauai Historical Society.)

The Grove Farm plantation manager's house near Nawiliwili Road was built in 1913. It is listed today as one of nine historical places in Hawaii in drastic need of repair. In its day, it was quite a showcase. (Courtesy Kauai Museum.)

Ray Jerome Baker took this photograph on July 13, 1960, after Sandie Knudsen Moir gave him a tour. The cactus garden was her hobby while Hector Moir was the manager of the Koloa Sugar Company. Since he had a home when he became manager in 1933, the plantation manager's home became the new Koloa Sugar office. Today the Moir home is the Plantation Gardens Restaurant. There are over 800 varieties of cacti in this extensive collection. (Courtesy Kauai Historical Society.)

This photograph of the Koloa Sugar Mill shows the cane haul trucks (lower left) loaded with harvested cane. Trucks replaced trains in the late 1950s. Although each mill had an extensive system of roads, cane haul trucks were a familiar type of vehicle on Kauai's roadways for a number of years. In the background is the majestic Mount Haupu, which can be seen at many locations along the south side as far away as Kalaheo. (Courtesy Kauai Museum.)

When Koloa Sugar Company celebrated its first 100 years on July 29, 1935, a granite Chinese cane crusher was on display. When Ladd and Company began, the Chinese were considered the authorities on crushing cane, and workers were imported from China. This crusher is similar to one on display today at Plantation Gardens Restaurant. (Courtesy Kauai Museum.)

This photograph shows a Fowler steam plow used by the Koloa Sugar Company in 1893. The company prided itself on always using the most modern equipment of the day. This plow replaced oxen pulling plows, but it never really took off in North America. They were popular in Germany in the 1890s. At that time, three Germans were in charge at the plantation. Paul Isenberg was president, W. E. Anton Cropp was manager, and Carl Ludwig Kahlbaum was head overseer. (Courtesy Kauai Museum.)

Lihue Plantation built a second mill in Hanamaulu in 1877. Theodore Severin took above photograph around 1890 showing the fields of sugarcane, the mill, and the bay of Hanamaulu. When the Chinese were brought in to work at the sugar plantations, their contracts stated that the plantation would provide food for the workers. Rice, the base for Chinese meals, was not available in Hawaii. It was not long before the Chinese were planting it along side the taro. Because of the diminishing Hawaiian population, demand for taro decreased, and rice took over the taro patches. The 1880s photograph below shows the sleepy village of Nawiliwili with a sailing ship in view. (Both courtesy Kauai Museum.)

This 1921 photograph shows the Hanalei Valley, once filled with *kalo* (taro), planted in rice. At one time, there were four rice mills, among them the Ching Young rice mill. Only the Haraguchi Mill survives today. Now the valley is full of kalo again and produces more than anywhere else in the state. The cycle has come full circle. (Courtesy Kauai Museum.)

Henry Funk took this photograph around 1900. It shows that besides sugarcane, Kealia had many acres devoted to rice. Beautiful Kealia beach is just visible in the background. (Courtesy Kauai Museum.)

In a Palama family album, this 1916 photograph was labeled "Hana hana in the pineapple fields." *Hana* means "working." At that time, the Kalaheo area was planted in acres of pineapple, and Hawaii was producing almost all the world's supply of the fruit. (Courtesy Kauai Museum.)

At one time, canneries were local landmarks, like the one in Kapaa. Robert Brooks Taylor took this interior photograph around 1950. The "Ginaca machine" was invented to quickly remove the shell and core. Currently this is the site of Pono Kai. (Courtesy Kauai Historical Society.)

By the time this photograph was taken in 1981, the cannery had already been closed for 20 years. The Kauai Pineapple Cannery, originally known as Kauai Fruit and Land Company, Ltd., was once a major part of Kauai's economy. It was in operation from 1907 until 1964. In its first year, the company produced 2,572 cases of pineapple and by 1925 had increased to 250,000 cases. The pineapple industry declined in the 1960s. It became cheaper to raise elsewhere. All three of Kauai's canneries closed in the late 1960s. Now remodeled, the property is Lawai Cannery Row Self Storage. (Courtesy Kauai Historical Society.)

# Five

# A Queen, a Scot, and an Architect

When one thinks of Lawai, one thinks of Queen Emma and lush plantings. That was not always the case. Lawai was somewhat barren. The entire ahupuaa of Lawai once belonged to Queen Emma's uncle and aunt. Her first visit was as a new bride of King Kamehameha IV, Alexander Liholiho, in 1856. Her life was not a very happy one. Both her husband and son died young. Although she had met Queen Victoria at Windsor Castle and Pres. Andrew Johnson at the White House, a sense of melancholy seemed to surround her. She even renamed herself Kaleleonalani, which means "the flight of the chiefs" in reference to the death of her husband and son. She had a home on a bluff that she called Mauna Kilohana where she spent the winter and spring of 1871. During that time, she had a ditch dug to bring more water, and she sent letters to family members for slips of various plants she wanted to plant at Lawai. Many of the plants and trees can still be found there today, such as the magenta bougainvillea, a gift from Dr. James W. Smith of Koloa. The bougainvillea can be seen cascading over the cliffs above where Emma's house was moved by the McBrydes. After the queen's death in 1886, Elizabeth McBryde, now a widow, bought the entire ahupuaa for $50,000. The upper lands were placed in sugarcane cultivation, and the valley was leased to taro and rice farmers. One son, Alexander, continued to expand the gardens the queen had started. The other son, Walter, went on to become the manager of the Kauai Pineapple Company but is better known as the owner of Kukuilono Park, which upon his death was given to the people of Kauai.

After Alexander McBryde's death, a 125-acre parcel was sold to Robert Allerton for $50,000. Allerton's partner, John Gregg, an architect from Chicago, designed gardens with rare and exotic plantings and renamed the estate Lawai-kai. Upon the death of John Gregg Allerton in 1986, the National Tropical Botanical Garden assumed management of the Allerton Garden for the Allerton Gardens Trust.

Queen Emma (left) married Kamehameha IV, Alexander Liholiho, in 1856. Prince Albert Edward Kauikeaouli Leiopapa a Kamehameha (below) was born on May 20, 1858. His English names were to honor the husband of his godmother, Queen Victoria of England, whom Emma met when she visited Windsor Castle. At birth, Albert was also given the title His Royal Highness, Prince of Hawaii. Not long after his fourth birthday, he became seriously ill and died in August 1862. Princeville, on Kauai, was named so to honor him. (Both courtesy Kauai Museum.)

The 1916 photograph of Queen Emma's house (above) and the view with unidentified people posing in front of the house in 1910 (below) show the house as it looked after it was moved from the cliff to the beach area. At this time, the McBryde family was living in it. All of Emma's slips that she gathered together from family and friends were mature and thriving plants now. In these photographs, the grandeur that became the National Tropical Botanical Garden is evident. (Both courtesy Kauai Museum.)

The area near the beach at Lawai was a wonderful place to entertain, as this c. 1910 photograph of the McBryde family having a picnic with friends shows. (Courtesy Kauai Museum.)

Taken from the beach area about 1910, the tall basalt rock formation to the right side of the photograph was called Puu Kiloia or "fish watching rock." Fish spotters would stand on top and direct the fishermen in canoes to the schools of fish. (Courtesy Kauai Museum.)

Duncan McBryde, a Scot, came with his wife, Elizabeth, to land he bought at Wahiawa, Kauai. He raised cattle and built a home called Brydeswood in 1860. Theodore Kelsey took this photograph of the view from the house. Mount Kahili is visible in the distance, and the reservoir right of center is now Kalawai Park. When Duncan died young at 52, Elizabeth continued to run the ranch and raise six children. She bought Lawai after the death of Queen Emma. (Courtesy Kauai Historical Society.)

Walter Duncan McBryde was the second son of Duncan and Elizabeth McBryde. During his young adult years, he learned about the lumber and the banking businesses, but he returned to Kauai in 1898 to help organize the McBryde Sugar Company. He was made manager of the Kauai Pineapple Company when it opened in 1906 and held that position until he died in 1930. (Courtesy Kauai Museum.)

This is the original entrance to Kukuiolono, the home of Water Duncan McBryde. The current entrance is made of lava rock and has a plaque on it that reads, "For my mother." He acquired 178 acres at public auction in 1907. The rest he purchased from individuals the same year until he had a total of 346 acres. A nine-hole golf course was built in 1929. It seems fitting a Scotsman built the second golf course on Kauai and the eighth oldest in the Hawaiian Territory. (Courtesy Kauai Museum.)

McBryde leased the remainder of his land to the Kauai Pineapple Company, and the rent went to the upkeep of the park. At his death, all the land was deeded into an irrevocable trust "to be used as a play and recreation ground for all time for the benefit of the public, regardless of race, color or creed." He left his life savings for its continued upkeep. This photograph of the Japanese Garden shows just one of the beautiful areas inside the park. (Courtesy Kauai Museum.)

Tsutomu Fujii took this photograph of the Kukuiolono Pavilion about 1920. It is built out at a point that has spectacular views of the entire south shore as well as mountain views. Although the building doesn't look quite as grand today, it is still a popular place to hold large outdoor parties. (Courtesy Kauai Historical Society.)

The Philip Palama family was raised on the Kukuiolono property. Philip Sr. was McBryde's right-hand man, and Mrs. Hisako Komaki Palama was his cook. McBryde had no children himself, so the Palama children were "his children." This gazing ball was just one of the intriguing things found on the property. (Courtesy Kauai Museum.)

The Kukuiolono House, built in the 1920s by Walter D. McBryde, took its name from the property. *Kukuiolono* means "light of Lono." In ancient times, the Hawaiians used the high ground to signal and guide fishermen at night. The house was far ahead of its time with its use of redwood as a building material and its many large windows. (Courtesy Kauai Museum.)

This photograph shows a large formal parlor with many archways giving it a very airy appearance that is a popular feature in new homes today. The glass-front double doors are to the back and to the right of the photograph. (Courtesy Kauai Museum.)

From this view, the glass-front french doors and entrance into the parlor are slightly to the right of center in the background. There was a fireplace area, not shown, as well as a room that housed McBryde's collection of calabashes (wooden bowls). Although there are some calabashes still in the Palama family, many were donated to the Kauai Museum. (Courtesy Kauai Museum.)

This was known as the telephone room. Note the telephone on the table to the left under the window. In the 1920s, telephones were still a luxury. Its airy feel and openness shows it was designed ahead of its time. (Courtesy Kauai Museum.)

Walter McBryde died in 1930 and donated the park and golf course to Kauai. During World War II, the army commandeered the house. It is said that the army's occupation took its toll on the house. After the war it was dismantled. This c. 1943 view of the property shows the Torii Gate, part of the Japanese Garden, with a soldier posing next to it. The soldier is looking out at the Pacific Ocean and the panoramic vista of the south shore of Kauai. The gate was taken down in the mid-1980s. (Courtesy Kauai Historical Society.)

According to photographer Ray Jerome Baker's diary, this photograph of John Gregg Allerton (right) and Robert Allerton (left) was taken in 1960 on a visit to their home Lawai-kai. They moved to Kauai permanently in 1938 and built a house near the beach. They kept Queen Emma's cottage for guests. They filled the home with art treasures and antiques from their many travels. Gregg designed many attractive water features on the property that visitors enjoy when they visit the National Tropical Botanical Gardens. The garden has many exotic and rare tropical plants that were collected by Gregg and Allerton. (Courtesy Kauai Historical Society.)

Lawai-kai has had myriad incarnations. It was once owned by Queen Emma, then the McBryde family from Scotland, philanthropist Robert Allerton of Chicago, and architect John Gregg Allerton. It has been the setting for many famous Hollywood movies, such as *Donovan's Reef* with John Wayne, *South Pacific*, *Last Flight of Noah's Ark*, *Honeymoon in Vegas*, and *Jurassic Park*. However, in this 1943 photograph, it was not a war movie being filmed. This was a picnic site for convalescing GI's during World War II. (Courtesy Kauai Historical Society.)

# Six

# MODES OF TRANSPORT

What are photographs of people doing in a chapter entitled "Modes of Transport?" The reason is poetic license. Photographers and their cameras for over 170 years have taken the less adventuresome on journeys of wonder. Viewers feel they have been there because they have seen photographs. This book is too small to properly honor the wonderful photographers whose work graces these pages. Most did not leave a photograph of themselves to share, but two did.

William Junokichi Senda (1889–1984) came here from Shimane, Japan, in 1906 at 17 aboard the *Hong Kong Maru*. He passed his physical but failed 15 eye exams in his immigration to Hawaii. From his success as a photographer, there was nothing wrong with his eyes. He bought his first Brownie Box camera in 1909. In May 1913, he heard about a photography business for sale on Kauai. It cost him $2.50 to travel steerage fare on the schooner *W.G. Hall* to Kauai, where he bought from Gokan's widow her husband's photography equipment and supplies for $75 and opened Senda Photo Studio in Kapaia on July 1, 1913.

Ray Jerome Baker (1880–1972) was born in Rockford, Illinois. He shot his first photographs in high school. After one semester at the University of Minnesota, he dropped out to become a traveling photographer. He met and married his wife and took her on a Hawaiian honeymoon in 1908. Their two-week vacation turned into four months. They moved permanently to Hawaii in 1910. He came to Kauai on several trips and recorded his thoughts in his diaries. On April 18, 1960, he wrote: "Called on Senda old time photographer. He introduced his son who is now a mature young man. Senda said he had retired and his son had now taken over. . . . Senda was very friendly and invited me to use his dark room."

Being an island county surrounded by water, Kauai has had its share of unusual means of transport. The outrigger canoes with sails are fully oceangoing and large enough to transport large numbers of people. Outrigger canoes are good for fishing and traveling from one inaccessible valley to another. In ancient times, these valleys were thriving, because most people walked or used canoes. Now, if a car or horse cannot get there, the traveler won't either.

When Senda had been in business two years, he wrote his father of his desire to find a wife and start a family. To his surprise, his father and grandfather had already found him one and had her officially registered as his wife. Senda called it "high-handed mischief" by his father and grandfather, but after looking at the photograph of his "wife," who looked "innocent and appealing," he did what they had asked and sent money for her passage to Hawaii. He finally had a hearty laugh over how "the two old fellows had certainly pulled a fast one" on him. Above is their formal wedding photograph. Their wedding was recorded October 23, 1915. (Courtesy Senda family.)

He brought his wife, Kayo Yamada Senda, home to Kapaia to a very primitive cottage with no running water or electricity. They had kerosene light, and water came from the stream that flowed behind the house. The Kapaia store was only a stone's throw away from the cottage, and it had utilities. Senda said Kayo never complained. This photograph is by Tsutomu Fujii. (Courtesy Kauai Historical Society.)

Lihue Plantation moved its stable and built the Tip Top Building in 1916. The main tenant was the Tip Top Restaurant and Bakery. The plantation asked Senda if he wanted to relocate his business to the second-floor space, and he said yes. He moved in on November 11, 1916, and his first child, daughter Eiko, was born on November 13,1916, where they lived at the back of the studio. (Courtesy Kauai Museum.)

W. J. and Kayo had a long and happy marriage that lasted 69 years. This photograph looks like an anniversary celebration, but actually this was taken on August 14, 1965, at a cocktail reception held at the newly built convention hall celebrating the opening of the new Senda Building. (Courtesy Senda family.)

When asked if W. J. had a favorite photograph, he replied in the negative. However, he did say, "I think Kauai contains more scenic beauty than any of the other islands. My favorite beauty spots on Kauai are some views of the Napali Cliffs and some of the vistas of Kalalau Valley." This is one of his photographs of Kalalau Valley, in ancient times one of the most populated valleys. (Courtesy Senda family.)

Ray Jerome Baker (1880–1972) signed this photograph of himself to Grace Buscher, manager of the Coco Palms Hotel in Wailua, in 1960. Baker and Senda were contemporaries, and both had reputations as fine photographers. Most postcards available during the first part of the 20th century were by either Baker or Senda. Baker was based in Honolulu and did more traveling to the outer islands. (Courtesy Kauai Historical Society.)

Besides walking, the outrigger canoe was the earliest form of travel on Kauai. According to journals written during the missionary period, even the missionaries used it as a preferred form of travel. This photograph was taken in 1900 looking up Makaweli Valley. (Courtesy Kauai Museum.)

In 1891, it would not be uncommon to see men from the local sugar mills riding oxen as transportation on their time off. Each plantation had many teams of oxen that were used to haul the sugarcane to the mills, and even the very first train cars were pulled by oxen, not locomotives. The first train was introduced in 1881, but they were not in use on a large scale until 1915. (Courtesy Kauai Museum.)

After horses were introduced to Hawaii in 1803, they became a popular form of travel among the islanders. *Paniolo* was a new word to describe a Hawaiian cowboy. This horseback rider around 1889 has just crossed the old Waimea Bridge, which was further inland than the bridge used today. (Courtesy Kauai Museum.)

Captain Vancouver introduced beef cattle to the islands in 1793. There were no deepwater wharfs on Kauai for ships to tie up to, so cattle were pulled into the surf to longboats, tied to gunwales and rowed out to waiting ships. Here some cattle are being taken from Kalapaki beach out to the waiting ship. (Courtesy Kauai Museum.)

This 1915 photograph by the Waimea Pier shows horses being off-loaded from a steamer. The process for off-loading horses was similar to cattle, except the horses were allowed to swim. Horses were introduced to the islands in 1803. One hundred years later, horses had replaced oxen as the preferred form of transportation. They were used to herd cattle as well as for more leisurely pursuits such as rodeos, polo matches, and horse races. (Courtesy Kauai Museum.)

This late 1800s photograph shows the Waimea River crossing to Makaweli. At the center right of the photograph, the road ends at the water's edge and takes up again on the other side. This area was near the Waimea suspension bridge and the Menehune Ditch. The horse-drawn buggy was a popular and practical form of travel over this shallow part of the river and dusty dirt roads. (Courtesy Kauai Museum.)

The first sugarcane was introduced in 1881. By 1915, there was 200 miles of narrow-gauge track used on the various plantations. None of Kauai's railroads was ever built for passenger travel. This is a photograph of a Lihue Plantation train. Today Grove Farm Museum has the largest collection of working steam engines in the world. (Courtesy Kauai Museum.)

Interisland steamship travel began on July 24, 1860, with the *Kilauea*. It was in service for 17 years, until 1877. The *Mauna Loa*, the *Likelike*, and others were to follow. The steamer *Waialeale* began interisland service to Kauai in 1928. Tsutomu Fujii took this photograph of the steamer in Nawiliwili Harbor. Fujii was a well-known local photographer who owned the Hale Nani Studio, which he sold in 1972. Many of his photographs were lost. This is one of those that remain. (Courtesy Kauai Historical Society.)

One of the first flights from Kauai was in May 1920. On board were Eleanor Scott Baydem and young pilot Charlie Fern, who came to the islands in 1919 as a barnstormer. He flew a two-cockpit, single-engine Jenny. Because he carried the first paying passenger on an interisland flight, he was given the honor of being the first commercial pilot in Hawaii. He worked for 44 years at Kauai's newspaper, the *Garden Island*, as a reporter, editor, and publisher. (Courtesy Kauai Historical Society.)

Local Kauai residents were excited to be on the first outbound flight to Honolulu in 1929 from Port Allen. Standing in front of the plane among some unidentified passengers are Daisy Wilcox (third from the left in white), Mary Waterhouse Rice (center wearing long white leis), and Arthur Rice (second from the right). Lihue Airport opened in 1949. (Courtesy Kauai Museum.)

# Seven

# A Bird's-Eye View

A very brief period of life on Kauai in 1924 was slipped into an aerial photographic time capsule thanks to the U.S. Geological Survey. Most of the photographs in this chapter were taken between July 4 and July 7, 1924, from approximately 300 to 1,000 feet in the air.

It is even more amazing to remember that this was in the very infancy of air flight. The U.S. Army and Navy were bickering over who should be flying. One year after these photographs were taken, the U.S. Navy decided to demonstrate seaplane flight from San Francisco to Honolulu, a distance of 2,100 nautical miles. This was further than the distance previously flown over the Atlantic Ocean. Today this is not considered risky at all, but back then, a Curtiss PN-9 had set a record for nonstop flight of 28 hours and 35 minutes. The plane's cruising speed was 70 knots. The distance to Hawaii would require a flight time of 30 hours. These early flight pioneers were hoping the tailwinds would supply the difference needed.

This set up the conditions for the August 31, 1925, flight that could have ended very badly. The pilot, Commander Rodgers, remembers they were so heavy with fuel that they had to fly for 50 miles before they could climb to 300 feet. The plane ran out of fuel and landed well at sea. The radio would receive but not send, and they heard radio communications between ships following them that indicated they were searching in the wrong location. On September 10, the crew of the plane saw Kauai's highest peak, Kawaikini, in the distance. A submarine sent out from Honolulu spotted them and towed them into Nawiliwili Harbor. The next day, the people of Kauai gave the crew of five a warm welcome. A destroyer was sent from Honolulu to pick up the men and deliver them to Honolulu, where Comdr. John Rodgers handed Gov. Wallace Rider Farrington the first letter to arrive in Hawaii by air. Of course, it arrived on Kauai first.

Valdamar Knudsen started the Kekaha Sugar Mill in 1856. This aerial was taken from 500 feet on July 4, 1924. Just four years before, it was the scene of Hawaii's first and only train robbery. The masked gunman was after the $11,000 payroll that was on the slow-moving train. Fortunately the robber was caught and sent to prison. (Courtesy Kauai Historical Society.)

Taken from 500 feet by the army corps for the territory of Hawaii on July 4, 1924, this image shows an excellent view of Waimea Landing with two ships at anchor, as well as the western shoreline. From this vantage point, one can see acres and acres of sugarcane growing in the foothills surrounding Waimea. (Courtesy Kauai Museum.)

This c. 1924 aerial photograph shows the once thriving Port of Koloa. Today it is a place where fishermen can easily put their boats in the water. The road off to the left leads to Spouting Horn. In the foreground at left is the area where the Whaler's Cove stands today. The road going to the right leads to the ocean side of Waikomo Stream Villas and the Sheraton Hotel. The primary road used today has not been built yet. (Courtesy Kauai Historical Society.)

This outstanding aerial view of Lawai-kai was taken around 1950 by Ray Jerome Baker. At the time, Robert Allerton owned the property. The river shows prominently in the center of the photograph. The river and beach have been the site of many Hollywood movies. Just out of view to the right is Spouting Horn. (Courtesy Child family.)

83

Hiram Bingham was not the best artist, but the 1821 drawing of Kapaa (above) does give a glimpse of what Kauai looked like to the first missionaries. Compare this to the aerial taken on July 6, 1924 (below). As with the drawing by Bingham, the Anahola Mountains, with their distinctive shape, are shown prominently. Their correct name is Kalalea. Bingham spent 20 years in the islands and is known as a popular preacher and teacher. He helped formalize a 17-letter alphabet that he used to translate the Bible into Hawaiian. The alphabet was later changed to 12 letters. (Both courtesy Kauai Museum.)

On July 4, 1924, the Wailua River and the old bridge (above) are featured. The Wailua is Kauai's largest and most navigable river. The lands to the right once belonged to Deborah Kapule, the last queen. It is where the Pohaku Hoohanau (birthstone) and Heiau Holoholoku are located. The cover photograph was taken from this area. The palm trees further to the right were planted by Mr. William Lindemann and became the future site of the Coco Palms Hotel. To the left of the river is the future site of Smith's Tropical Paradise and Wailua Marina. At the left in the foreground is the site of seldom-seen petroglyphs and the Heiau Hikinaakala. Nonou Mountain, or Sleeping Giant, is seen behind. In the aerial photograph (below), taken on the same day, Wailua is shown without Lydgate Park or the Aloha Beach Resort. Three beachcombers are returning to their car after an uncrowded Fourth of July outing. (Both courtesy Kauai Historical Society.)

This photograph of the Kilauea lighthouse was taken shortly after it was built. Construction for the lighthouse began in 1912, and it was dedicated on May 1, 1913. Workers building it had to dig down 11 feet to find solid volcanic rock, so this lighthouse has a basement. Inside the 52-foot-tall tower is a four-and-a-half-ton Fresnel lens manufactured in France. It was decommissioned in 1976 and placed on the National Register of Historic Places on October 19, 1979. (Courtesy Kauai Museum.)

This July 4, 1924, photograph shows Kilauea Point, a narrow lava peninsula, and its lighthouse, which once had the distinction of being the westernmost lighthouse in the United States and could be seen 21 nautical miles away. In 1985, Kilauea Point became part the U.S. Fish and Wildlife Service as a national wildlife refuge. (Courtesy Kauai Museum.)

From 300 feet up, it is clear that a major Fourth of July party is going on at Kilauea Beach. Note the line up of Model T–type cars and rafts out in the middle of the water. Kilauea and it nearby refuge are home to nesting seabirds such as the red-footed booby, the Laysan albatross, and the frigate bird with its spectacular 8-foot wingspan. (Courtesy Kauai Museum.)

This military survey photograph from 1928 of Nawiliwili and Lihue shows the harbor before it was dredged or before a jetty was built. It also shows the Kalapaki beach area prior to the building of either the Kauai Surf, the Westin, or the Kauai Marriott. Looking at the right foreground of the photograph, one sees only sugarcane. It is now a manicured golf course with breathtaking ocean and mountain views. (Courtesy Child family.)

This aerial photograph of Lihue, taken on July 6, 1924, by the army corps at 300 feet, gives a great view of many of its prominent buildings at that time. The large white building to the left of center is the Kauai county building, constructed in 1913. Notice how small the palm trees are. The Kauai Museum at that time was the Lihue Public Library. Its distinctive roofline is just above the county building. The large structure to the right of both buildings is the Lihue Ball Park grandstand, which is now the site of the state building on the corner of Hardy and Eiwa Streets. Above and to the left of the grandstand is the distinctive front facade of the Tip Top Building. Farther left is the smokestack of the Lihue Plantation sugar mill. (Courtesy Kauai Museum.)

# *Eight*

# You Can't Get There from Here

This chapter is dedicated to things that no longer exist or are extremely difficult or impossible for the average person to get to today. Some places only exist in old photographs and Kauai's collective memory.

The dominant feature seen from many places on Kauai is Mount Waialeale. In ancient times, the chiefs made yearly sojourns to the summit to make offerings at the *heiau* (temple, shrine). It is often referred to as the wettest spot on earth. In the archives of the Kauai Museum are such titles as *The Ascent of Waialeale, Kauai, September 14–18, 1874* by George H. Dole. He recounts two other ascents made in October 1862 by himself and Messrs. George Rowell and Johnson from Waimea and in March 1870 by George N. Wilcox among others from the Wailua side. He writes his dramatic narrative of this last ascent:

> It is about noon when we reached the junction of the spur we were ascending with the main ridge. After a short rest and a little refreshment we went on along the narrow road, now up and now down; a vast abyss on either hand. Soon we arrived at the foot of the steepest climb on the whole route. The ridge rises abruptly at an angle of about 70 degrees to the height of over a thousand feet. Were it not for the thick tangled growth of trees and vines and bushes, which cover this pali, it would be utterly impossible to ascend it. But for every step one takes there is a root, or a branch, or a slender sapling, or a swinging vine just overhead within reach of the hands. Such mountain climbing as this is magnificent exercise. Half the time the body is lifted perpendicularly by the arms alone.

Privileged few ever reach the summit, and even fewer have seen it in sunlight. Most often it is shrouded in cloud, fog, mist, rain, or any combination thereof. The trails are ill defined, and pig runs everywhere add to the confusion. In a 1937 story, Honolulu attorney Clifton H. Tracy writes, "You grasp what you think is a large branch and when the water is squeezed from it by your grasp you find that you have hold of a small twig."

William V. Hardy (1863–1950) was the resident U.S. Geological Survey hydrographer on Kauai from 1911 to 1920. He made 22 trips up the mountain, 14 alone. Previous to his arrival, W. F. Martin had placed a 50-inch rain gauge on the mountain. It had to be read monthly and was often found overflowing. In 1915, Del Horner and Hardy carried a 300-inch gauge on their backs. It was replaced with a larger one in 1928. Hardy said, "Many times I took out my compass and was astounded to find we were going backwards, or sideways, any direction but the right one!" This photograph was taken in 1920. (Courtesy Kauai Museum.)

Many have tried to re-create in words the Mount Waialeale hiking experience. Even this photograph of three unidentified men and their dog makes the experience appear tame. It has been described as tramping through mud, fog, and bogs. In 1937, the *Honolulu Star Bulletin* asked William V. Hardy about his memory of the trips. He said, "It is a miserable trip. Try to imagine wading through mud in a tunnel cut through a dense overhanging jungle." (Courtesy Kauai Museum.)

These three unidentified men stand reflected in the lake called Waialeale, which means "rippling water." The lake is small, about 75 feet in diameter and only 2 to 3 feet deep, with very cold water. (Courtesy Kauai Museum.)

The heiau (above) on top of Mount Waialeale is called Kaawako. According to Edward Joesting in his book, *Kauai: The Separate Kingdom*, the altar stands 2 feet high, 5 feet wide, and 7 feet long with two lava slabs. In ancient times, it was here chiefs and priests came to honor their god Kane and pay respect. The shrine (below) is where offerings were left to Kane for a safe return trip down the mountain. These unidentified men are not Hawaiian, but neither are they willing to leave without leaving an offering for a safe journey back down the mountain. (Both courtesy Kauai Museum.)

The large amounts of rain on top of Mount Waialeale required ever larger and easier-to-use rain gauges. This photograph is of Hulu Taniguchi (right) and another man in 1928 carrying up a gauge that could hold 900 inches. (Courtesy Kauai Museum.)

From left to right, Hulu Taniguchi, unidentified, and Hulu's son Eddy Taniguchi pose on top of the mountain with the rain gauge in 1928. Finally, the 900-inch gauge could be measured once a year without fear it would overflow. (Courtesy Kauai Museum.)

Hulu Taniguchi (left) is shown here with Max Carson. Hulu was the only guide to lead U.S. Interior Department scientists up the mountain in the early 1930s. (Courtesy Kauai Museum.)

Before helicopters, Hubert W. Beardin was one of the men who trekked up Mount Waialeale to take rain-gauge readings. On one such trip in July 1948, he had a heart attack and died within 300 feet of his goal. It took 16 men three days to bring his body back. (Courtesy Kauai Museum.)

In March 1969, a Japanese-made recorder that charts minute-by-minute precipitation on the mountaintop was installed. By the 1980s, the men who work for the U.S. Geological Survey to collect the rain-gauge readings used helicopters. They contracted with Jack Harter to fly them up to the summit to take quarterly readings. Bev Harter took this photograph of Noriaki Kojiri, Roy Taogoshi, and Kenneth Konishi. (Courtesy Kauai Museum.)

According to Nori Kojiri, he ducks beneath the helicopter blades, quickly but carefully removes the chart from the machine, replaces it with another, notes the rain level inside the gauge, opens a spigot and lets the water run out, closes it when it is empty, jumps back into the helicopter, and says, "Let's go." The mission is accomplished in less than 15 minutes—not like the old days. (Courtesy Kauai Museum.)

Theodore Severn photographed the area known as Nonopapa around 1890. This is on the leeward side of Niihau facing away from Kauai. Niihau is 69.5 square miles and lies 17 miles southwest of Kauai. The Robinson family owns the island and respects the Hawaiian people who live there rent-free. At the time of the 2000 census, there are 160 residents. (Courtesy Kauai Museum.)

This early 1890s photograph is said to be of Eliza Sinclair's son Francis, who was named after his father. When Eliza Sinclair passed away in 1892, Aubrey Robinson took over running Niihau. Visitors were allowed on Niihau until the 1930s, when an epidemic led to the death of 11 children from measles. (Courtesy Kauai Museum.)

Although this structure no longer exists, it was once the home of Lester Robinson, a greatgrandson of Elizabeth (Eliza) Sinclair of Edinburgh, Scotland, who bought the island of Niihau from King Kamehameha IV for $10,000 in 1863. This house was perched on a cliff at the entrance of Olokele Canyon. Imagine the difficulty in building a house in such a remote area. (Courtesy Kauai Museum.)

Part of the *Na Pali Moku*, meaning the "cliff district," is Nualolo. It is the driest of the Na Pali ahupuaa. Now this area is cut off from the rest of the island due to high, impassable ridges, but there are many indications of a flourishing community as far back as 600 A.D. In summer months, this ladder makes the beach accessible from above. This is an area known for its good fishing. In the winter months, the beach might not be visible at all. (Courtesy Kauai Historical Society.)

*Nualolo* means "brains heaped up." Its natural beauty defies its name. These horseback riders in 1913 came to see the view. The riders at the opening of Nualolo Trail are Ruth Knudsen (in front), Mrs. Val Knudsen, Mr. Arana, Miss Fisher, Mrs. G. Ewart, Mr. Hitchcock, Mrs. William Danforth, Jack Northrop, Moki, and Masa. (Courtesy Kauai Historical Society.)

In 1900, Kauai was as an idyllic paradise with lush vegetation, waterfalls, and grass huts. Thanks to engineer and photographer Henry Funk, it has been captured on film for everyone to see. (Courtesy Kauai Museum.)

W. J. Senda took this photograph of the Na Pali Cliffs in the mid-1900s. The Kalalau Trail is visible on the first slope. Seventeen-inch treads are standard for hiking trails; Kalalau has an 11-inch tread. The Sierra Club ranks trails by difficulty and beauty from 1 to 10. The Kalalau Trail is one of the few ranked as a double 10. (Courtesy Senda family.)

Possibly the most beautiful waterfall on Kauai is Manawaiopuna. It means "stream branch of Puna." It is sometimes called Hanapepe Falls. At one time, it was a popular waterfall to visit. It is rarely seen today unless by helicopter. (Courtesy Kauai Museum.)

Waipahee means "waterslide." This very popular natural slide is no longer open to the public. The mountain water that feeds the slide is very cold, but it was a great way to spend a summer Sunday afternoon. This photograph was taken by Henry Funk around 1900. (Courtesy Kauai Museum.)

Slippery Slide in Kilauea was also known as South Pacific Slide. The slide was built for the movie *South Pacific* and has a small concrete plaque stating so. It was a favorite visitor destination until some litigious people wanted to sue the county. No one is allowed to swim there anymore. (Courtesy Kauai Museum.)

Although visitors can visit the Wailua Falls today, it is normally viewed from the left side of the Wailua River. This view, taken by Theodore Severin in the 1890s from the right side of the river, gives a much different perspective to the falls. (Courtesy Kauai Museum.)

On a cliff overlooking the Pacific Ocean stood the Henry Birkmyre (1867–1944) home. Henry came to Kauai from Scotland in 1888 and was employed by Kilauea Sugar Company, where he became head overseer. These two views from the Hanalei Stream are of the home, which was used as French planter Emile de Becque's home in the film *South Pacific*. A year later, the property was sold, and the Hanalei Plantation Hotel was built. Neither the house nor the hotel exist today. (Both courtesy Kauai Museum.)

With the Hanalei Mountains for a backdrop, Rossano Brazzi woes Mitzi Gaynor in the movie *South Pacific*, filmed on the Miranda Birkmyre property and released in 1958. (Courtesy Kauai Historical Society.)

One of the main subplots of the film *South Pacific* revolves around Nellie Forbush's inbred bigotry. She is shocked by her response to the planter's two mixed-race children, who she finds charming on one hand and somehow sinful and wrong on the other. The movie used humor and song to address the theme of ignorance about other cultures. (Courtesy Kauai Historical Society.)

These petroglyphs are largely unknown because they are rarely visible. This lucky beach walker in 1916 was fortunate to come across them uncovered. Keoneloa Beach, commonly known as "Shipwrecks," was named for a shipwreck. Hurricane Iwa washed away the remains. Note the rock cliff formation made famous by Harrison Ford and Anne Heche when they jumped off it in the movie *Six Days, Seven Nights*. (Courtesy Kauai Museum.)

The Keoneloa Petroglyphs can be covered by sand for years. Then due to some change in wave action, they become visible again. This example is of a boat with a crab-claw sail. This kind of boat was used by the ancient Hawaiians to navigate the seas. (Courtesy Kauai Historical Society.)

*Hukilau*, which literally means "pull ropes," was a common way the ancient Hawaiians would fish as a group event. Most people today only see a hukilau represented on stage in a hula at a tourist luau, but in 1939, these people were involved in the real thing at Keoneloa Beach, which fronts the Grand Hyatt Hotel in Poipu. (Courtesy Kauai Museum.)

In January 1980, after two winter storms, a wonderful display of petroglyphs was visible at Mahaulepu Beach. The large sandstone shelf had been unseen for over 50 years. It is usually buried under 6 feet of sand. Local resident Reva Stiglmeier was fortunate to be there with her camera. The sand was already burying the petroglyph again by day two. Bill Kukuchi, anthropology professor at Kauai Community College, said most designs were prehistoric. (Courtesy Reva Stiglmeier.)

At the mouth of the Wailua River near Heiau Hikinaakala, "rising of the sun," are some petroglyphs. In this May 1949 photograph taken by Rebecca Banks, researcher Jacob Freid stands by a rock formation labeled "poi bowl." It is a smooth area that was possibly used to grind the taro into poi. These petroglyphs are elusive to view, as are all that are at the water's edge. (Courtesy Kauai Historical Society.)

Honolulu photographer Ray Jerome Baker came to Kauai several times to take photographs. This was taken on a visit in 1912. Although he did not have to hunt to see poi making in 1912, it would be difficult to find today. Most Hawaiians don't grow their own taro but buy poi at the supermarket. Not commonly found in mainland markets, poi is still easily found on Kauai. (Courtesy Kauai Historical Society.)

The Coco Palms Hotel became legendary under the capable hands of Grace Buscher Guslander. From 1953 to 1985, it was the place to stay. The lagoon, made famous by Elvis in *Blue Hawaii*, was visited yearly by an equally famous gentleman, Santa Claus, as this December 22, 1958, photograph shows. The hotel was severely damaged by Hurricane Iniki in 1992 and has never reopened. (Courtesy Kauai Historical Society.)

Severin took this photograph of Kapaia around 1890. Even now Kapaia is a sleepy village just outside Lihue. Chinese and Japanese primarily settled the area. They raised rice and watercress. Looking up and to the right of the planted rice is Immaculate Conception Church, which was established in 1884 and is still a quaint church one can visit today. The small buildings on the right are outhouses. (Courtesy Kauai Museum.)

In 1890, when Severin photographed this hale pili, they were not hard to find, nor was pili grass. Pili grass has a thick, waxy cuticle that makes it strong, waterproof, and a perfect thatch material. The grass is applied to the inside structure, root ends down first, and the outer-layer bundles are thicker, with root ends up. Rain then runs down the sides of the hale. The technique is similar to using shingles on modern houses. Fishnets are thrown over the grass until the pili has completely died to avoid curling. The hut shown here does not have a lanai, but the one on the cover of the book does. A lanai or windows were adaptations of some western-style houses. The original meaning of *lanai* is a temporary roofed structure with open sides near the house. Now it means a porch or veranda. Often the interior was thatched with *lauhala* (pandanus leaves). The floor was covered with woven lauhala mats. Hawaiians used little or no furniture, preferring to sit or sleep on the floor. (Courtesy Kauai Museum.)

# Nine

# Kaikioewa and Lihue

Lihue never was an ahupuaa. It is in the Puna moku and was the dream of two very different men. First was Kaikioewa, the first governor of the Kauai after the death of King Kaumualii. He was sent over to put down the uprising of the king's son, George Humehume. After he accomplished this, he was appointed governor. Being a warrior first, he ruled Kauai with an iron hand. As he aged, and as he came more under the missionaries' influence, his demeanor softened. Some time between 1835 and 1838, he had a home and church built in the Lihue area. It is thought that he named it after another Lihue near Wahiawa on Oahu. *Lihue*, meaning "cold chill" or "gooseflesh," has little to do with Kauai's Lihue. The area where the house and church stood is now near the present Lihue Post Office and the Bank of Hawaii. He planned to grow sugarcane there but died unexpectedly in 1839. Any further plans he had for the area were never realized. The second dreamer was a New Englander from a Boston merchant family, Henry Augustus Peirce. He went to sea at 18, seeking opportunities everywhere from the Gold Rush in California to Canton, China. It was on a stopover on his way to China that Peirce first dreamed of a sugar plantation in the sleepy village. With Honolulu friends Charles Bishop and Judge William Lee as partners and $16,000, Henry A. Peirce and Company was formed in 1849. The very first crop produced 108 tons of sugar and 25,847 gallons of molasses. In 1859, the name was changed to Lihue Plantation Company. Paul Isenberg joined the plantation in 1858 and became manager in 1862. He was manager for 20 years. Once only 3,000 acres, the plantation increased to over 50,000 acres owned or leased by 1878. By 1933, Lihue Plantation owned the Makee Plantation, Ahukini Railway Company, Nawiliwili Transportation Company, East Kauai Water Company, Princeville Ranch, Waiahi Electric Company, and pineapple lands leased to Hawaiian Canneries. None exist today. The plantation closed in 2000 due to economic changes.

Theodore Severin took these photographs around 1890. Above is the Alekoko Fishpond along the Hulaia River. Modern anthropologists believe the fishpond was used as far back as 1350 A.D. The beauty of a fishpond was that it easily provided fresh fish of many types at all times, in all seasons, and all climatic conditions. Fishponds showed a chief's ability to provide for his subjects. The horses in the foreground are in an area covered by mangroves today. Below, Niumalu, an area near the Alekoko Fishpond, is shown as quite barren. The area now is lush with plants and vegetation. (Both courtesy Kauai Museum.)

The most changed area near Lihue is around Nawiliwili. In 1915, it had the look of a small fishing village. After it was dredged for a deepwater harbor in the late 1920s, nothing looks familiar. (Courtesy Kauai Historical Society.)

Senda took this view of Nawiliwili Harbor in the late 1950s. The quaint fishing village is gone and replaced by an industrial area. One of the new buildings is Club Jetty (lower center), a favorite nightspot. Club Jetty was opened in 1946 by Emma "Mama" Ouye. Among her famous clientele was John Wayne. Hurricane Iniki destroyed it in 1992. Mama Ouye died in 2007 at age 99. (Courtesy Senda family.)

This c. 1913 photograph shows Rice Street coming up from Nawiliwili in a quieter time. Note that the only traffic is a single horse-drawn cart. The large white building in the distance is the new county building. (Courtesy Kauai Museum.)

The Fairview Hotel, sometimes referred to as the Lihue Hotel, is seen in this 1890 photograph taken by Theodore Severin. This building stood on Rice Street where the Kalapaki Villas are today. Note the two blurred images. A dog and a chicken could not stand still long enough for the photograph. (Courtesy Kauai Historical Society.)

This is an aerial photograph of the Kauai Inn looking east around 1945. The buildings right of center were cottages visitors could stay in as well. The tall two-story house on Rice Street facing west belonged to the Moragne family. The War Memorial Convention Hall would be built in the sugarcane field to the left in 1964. The managers were Wayne and Helen Ellis. (Courtesy Child family.)

The Kauai Inn on Rice Street, where Kalapaki Villas are today, was the only competition for the Coco Palms back in the 1960s. Tsutomu Fujii took this photograph. (Courtesy Kauai Historical Society.)

The Kress dime store building on Rice Street, now the Salvation Army Thrift Store, signals the turn onto Kress Street to the famously hidden mom-and-pop eateries Hamura Saimin and the BBQ Inn. (Courtesy Kauai Museum.)

The Lihue County Building was the first county structure erected in the territory. This photograph by Ray Jerome Baker was taken shortly after it was built in 1913. It was dedicated in 1914. (Courtesy Kauai Historical Society.)

At one time, a road led directly to the county building. After Jacqueline Kennedy restored the White House, there was a resurgence of civic pride at the local level. In 1971, under Mayor Antone Vidinah's administration, new lighting was installed among other additions. The road was filled in and the park was created. (Courtesy Kauai Museum.)

In 1922, Mrs. Emma Kauikeolani Wilcox donated $75,000 for a public library. In 1923, Lihue citizens stand proudly on the steps at the opening of the Albert Wilcox Memorial Public Library. This building is now the home of the Kauai Museum. (Courtesy Kauai Museum.)

William Hyde Rice (above, left) and his wife, Mary Waterhouse Rice (above, seated with hat), are pictured with two friends sitting on the steps of their home. They named their home Hale Nani, which means "pretty house." The home no longer exists. Back in 1890, it was situated where Photo Spectrum on Umi Street is today. William Rice (below, right) and an unidentified man are shown next to a *hale pili* (grass hut) on his property. Queen Liliuokalani appointed Rice as governor of Kauai from 1891 until the overthrow of the monarchy. (Both courtesy Kauai Museum.)

The wooden two-lane bowling alley above, in the center of the German community in Lihue, was known as the German Bowling Club. It was near the present-day post office on Rice Street. The Isenberg Memorial, below, is a little closer to the mill on the same side of the street. Paul Isenberg was a manager of Lihue Plantation for 16 years, from 1862 to 1878. During his leadership, the plantation grew from 3,000 acres to over 50,000 acres. He brought a forester from Germany and spent $10,000 to reforest the land that had been cut down to fuel the plantation. Isenberg was beloved in the community, and the memorial was erected April 15, 1904. (Both courtesy Kauai Museum.)

One area of Lihue that has undergone some of the most dramatic changes over the last 100 years has been where Rice Street, Haleko Road, and Government Road (now Kuhio Highway) converge. It happens that Lihue Store was right at that intersection, so watching Lihue Store, one can see the changes over time. Above is the store around 1905. The Isenberg Memorial is visible in the background and the seedling false kamani tree in front. Below are the store in 1916 and the more mature false kamani tree. (Both courtesy Kauai Museum.)

W. J. Senda took these two photographs of Lihue Store in 1919. Above, the wooden store has been replaced by a concrete building and is now known as Lihue Store, Kauai's Emporium. Note that the false kamani tree out front has been preserved and grown much larger. Senda, below, captured this interior view of Lihue Store. He is standing by the soda fountain looking out the front door. (Both courtesy Kauai Historical Society.)

Standing under the false kamani tree in front of the Lihue Store in 1919, the corner of Haleko Road and Rice Street is very visible. Just out of the photograph to the left is the Isenberg Memorial, which is still there today, as well as the rebuilt German houses on the right. (Courtesy Kauai Historical Society.)

For anyone not born in 1919, this view of Lihue Store from the Isenberg Memorial across the street makes it very easy to see where Lihue Store was originally located. This photograph was probably taken in the late 1920s, considering the size of the false kamani tree. (Courtesy Kauai Historical Society.)

Another Lihue landmark visible today is the marble lion fountain that now stands in front of the restored German houses (now offices) at the corner of Haleko Road and Rice Street, but that was not the fountain's original location. It was originally across the street from Lihue Store, seen above. The fountain was bought by Rev. and Mrs. Hans Isen Isenberg in Florence, Italy, in 1909 as a gift to Kauai. Contrary to what the photograph below implies of a man washing up, the fountain was actually a fancy watering trough for horses. (Courtesy Kauai Museum.)

This c. 1920 aerial photograph shows the Lihue Store (center) and the distinctive area around the Isenberg Monument, the back side of Tip Top Building, the library, the county building, and the Lihue Ball Park grandstand. In the background is nothing but sugarcane. Often people have difficulty pronouncing *Haleko* correctly. The road runs past the Isenberg Memorial right through the Lihue Sugar Mill, or *Hale Ko*, "house of sugarcane." (Courtesy Senda family.)

The next big building boom came in 1964. Where the Lihue Store was is now the parking lot for the round building. Lihue Store could be found within the larger Lihue Shopping Center complex. When the new road connected up to Haleko Road, it was renamed Kuhio Highway after Prince Kuhio. The white county building is still visible but is blocked by some trees. The very new War Memorial Convention Hall, with its napkin-shaped roof, is visible above Rice Street. (Courtesy Kauai Museum.)

The War Memorial Convention Hall was dedicated December 4, 1964, after 30 years of planning and raising funds. The first bond was approved in 1937, when Hawaii was still a territory and World War II had not been fought. The land was purchased from Lihue Plantation in 1955 for $50,050. The architect was Clifford Young of Young and Henderson, and the building was constructed at a cost of $700,000. Its parabolic double-arched roof of laminated wood is the first structure of its type in Hawaii. In 2001, it received a $372,000 face-lift. (Courtesy Kauai Museum.)

Kukui Grove opened in 1982. It is 35 acres and Kauai's only mall. Note a portion of the name "Liberty House" at the far right of the photograph. Liberty House bought out Lihue Stores in the 1970s. Macy's has since bought out Liberty House. Grove Farm sold the mall in 2005. The new owners did a major remodel, updating the look to attract a number of new tenants, among which are Starbucks, Jamba Juice, Blockbuster, Coldstone Creamery, and Quiznos. (Courtesy Kauai Museum.)

Haleko Road has not been seen like this in recent memory. The cars are driving toward Rice Street. Where the people are standing is a large mill building now. The steam engine Paolo, at the Grove Farm Museum, still uses the train tracks for short historical rides. Halfway down the picture to the left is a road to German Hill that isn't there now. (Courtesy Kauai Museum.)

Although Kaumualii Highway has changed considerably since this 1920s photograph was taken, because of the bridge being visible most should be able to get their bearings. The road leading to German Hill is just visible center left. Tsutomu Fujii was the photographer. (Courtesy Kauai Historical Society.)

Known as Lihue Bank in this c. 1930 image, this business became the Lihue Bank of Hawaii. It stands on property that once belonged to Governor Kaikioewa. Kauai's first historian, James Jackson Jarves, writes about the property in his two books about Hawaii, *History of the Hawaiian Islands* and *Scenery in the Sandwich Islands*. The books were both published in 1843. (Courtesy Kauai Museum.)

The 1939 photograph shows the local landmark Lihue Theater, with its marquee promoting a Ritz Brothers film that starred Patsy Kelly as Kitty the maid and Bela Lugosi as Peters the butler. The theater was recently renovated into a senior citizens' home. The Shell gas station is still in the same location. (Courtesy Kauai Museum.)

The Lihue Bandstand (above) was on Rice Street on the same side and to the front of the County Building. Brass bands like the Lihue Brass Band (below) were popular at the beginning of the 20th century. These new instruments were mass-produced, and the new valves made them easier to learn. All the instruments used the same fingerings, so it was easy to switch instruments. (Both courtesy Kauai Museum.)

Sumo wrestling was introduced to Hawaii in 1885, the same year Japanese immigrants arrived. Henry Funk took the photograph above around 1900. Sumo wrestlers train to build up large muscle mass and eat a special diet to gain as much body weight as possible. Those pictured seem slim. Professional sumo is practiced only in Japan. It is interesting to note that it was not until 1993 that Akebono became the first Hawaiian-born *yokozuna*, sumo's top rank. W. J. Senda took the photograph below of grand sumo wrestlers at a tournament held at the Lihue Ball Park in 1914. (Both courtesy Kauai Museum.)

# Discover Thousands of Local History Books
# Featuring Millions of Vintage Images

Arcadia Publishing, the leading local history publisher in the United States, is committed to making history accessible and meaningful through publishing books that celebrate and preserve the heritage of America's people and places.

Find more books like this at
**www.arcadiapublishing.com**

Search for your hometown history, your old stomping grounds, and even your favorite sports team.

Consistent with our mission to preserve history on a local level, this book was printed in South Carolina on American-made paper and manufactured entirely in the United States. Products carrying the accredited Forest Stewardship Council (FSC) label are printed on 100 percent FSC-certified paper.

**MADE IN THE USA**